Advancing American Art

Politics and Aesthetics in the State Department Exhibition,

1946-1948

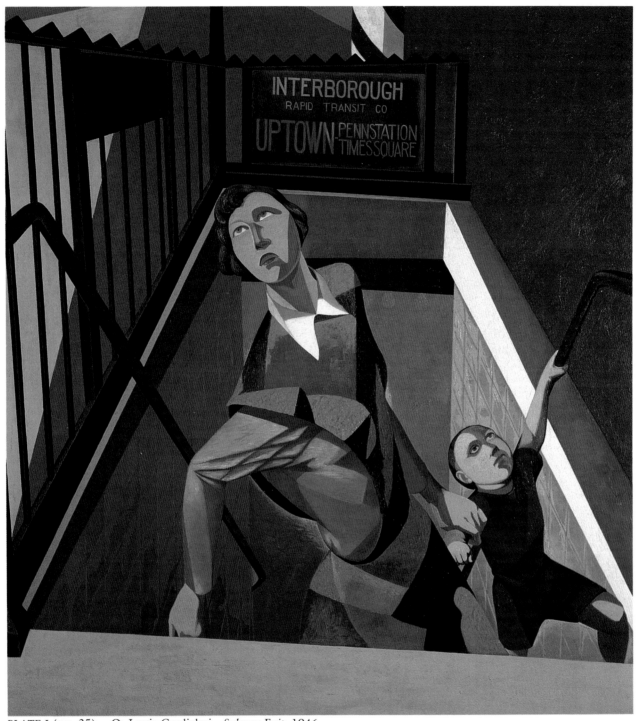

PLATE I (no. 35) O. Louis Guglielmi *Subway Exit*, 1946

Advancing American Art

Politics and Aesthetics in the State Department Exhibition,

1946-48

Essays by

Margaret Lynne Ausfeld and Virginia M.Mecklenburg

Montgomery Museum of Fine Arts
Montgomery, Alabama
1984

Library of Congress Cataloging in Publication Data

Mecklenburg, Virginia, 1946-
 Advancing American art.

 Exhibition held at Montgomery Museum of Fine Arts,
and at other galleries, Jan. 7-Dec. 9, 1984.
 Bibliography: p. 91
 1. Painting, American—Exhibitions. 2. Painting,
Modern—20th century—United States—Exhibitions.
3. Avant-garde (Aesthetics)—United States—History—
20th century—Exhibitions. I. Ausfeld, Margaret Lynne,
1953- . II. United States. Dept of State.
III. Montgomery Museum of Fine Arts. IV. Title.
ND212.M44 1984 759.13'074'014 83-19301
ISBN 0-89280-021-6

Exhibition Schedule

Montgomery Museum of Fine Arts, Montgomery, Alabama
January 10 through March 4, 1984

The William Benton Museum of Art, Storrs, Connecticut
March 17 through May 6, 1984

The National Museum of American Art,
Smithsonian Institution, Washington, D.C.
June 1 to October 8, 1984

Terra Museum of American Art, Evanston, Illinois
October 21 to December 9, 1984

This project is supported by grants from the National
Endowment for the Arts in Washington, D.C., a federal agency;
the Alabama State Council on the Arts and Humanities; the
Committee for the Humanities in Alabama; and the Blount
Foundation, with additional funds provided by Auburn
University.

Contents

Lenders to the Exhibition

Auburn University
Auburn, Alabama

Georgia Museum of Fine Arts
The University of Georgia
Athens, Georgia

Henry Art Gallery
University of Washington
Seattle, Washington

Honolulu Academy of Arts
Honolulu, Hawaii

The Jane Voorhees Zimmerli Art Museum
Rutgers University, The State University
New Brunswick, New Jersey

Lancaster County Art Association
Lancaster, Pennsylvania

Museum of Art
University of Oklahoma
Norman, Oklahoma

New York Mills Union Free School
District
New York Mills, New York

Owego Apalachin Central School District
Owego, New York

Mr. and Mrs. Stephen A. Seidel
Philadelphia, Pennsylvania

Washington County Museum of Fine Arts
Hagerstown, Maryland

United States Information Agency
Washington, D.C.

Foreword

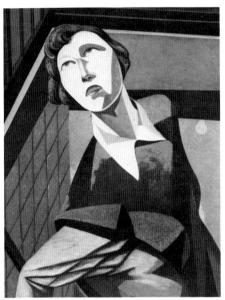

Subway Exit (detail)

In Louis Guglielmi's painting *Subway Exit* (frontispiece) a young mother and her child are seen emerging from a subway station stairwell into a deserted New York City street. The woman looks up anxiously as if fearing trouble; the child struggles behind her, extending his arm to the railing he can barely reach and straining to lift his short legs over the steps. Various formal elements contribute to the painting's sense of disquietude. The flat, intensified colors and crisp outlines bring a harsh urban glare to the scene, and the exaggerated perspective and skewed angularity of the composition create a subtle feeling of unease and hostility.

This work, included in the 1946 State Department show that the present exhibition reassembles and documents, might well be said to symbolize the bold yet apprehensive artistic climate of post-war America. For while the painting reflects a borrowing from practically all the European art movements that achieved notoriety early in the twentieth century—Fauvism, Cubism, Expressionism, Surrealism— it also suggests the relative stylistic timidity of the American artists who borrowed from them, and perhaps their wariness about public acceptance of their work. For if progressive American artists saw themselves advancing from a musty, subterranean world of conventional realism into the rude, clear light of European modernism, they also found to greet their efforts a puzzled and increasingly angry American public—aesthetic "muggers" who sought to violate and discredit their innovative styles. It is the exact character of this "advanced" American art produced in the 1930s and 1940s, as

well as the critical and public reaction to it, that the present exhibition explores.

Advancing American Art was not the first instance of public rejection of modern art in this country. A precedent more widely remembered is the infamous 1913 Armory Show when examples of European painting by such masters as Cézanne, Van Gogh, Matisse, and Duchamp were subject to vituperative ridicule by the American public. In some ways, though, *Advancing American Art* was perceived as an even more disturbing phenomenon, for it could not be dismissed as the work of decadent or mentally deranged foreigners. Rather it consisted of art that was produced by Americans, and that the U.S. government had seen fit to purchase with public funds. Now here was food for scandal! The re-presentation of such an exhibition tempts the thoughtful observer to consider the relation of innovative art to public tastes today. While many of the great modern European masters first presented in the Armory show are now universally admired, it still cannot be said that abstract art has found a broad, receptive audience in this country. However, there does seem to be even in the most conservative circles an acceptance of the idea that a work of art can be considered as an independent entity, that a painting's aesthetic virtues need not be linked to a political or philosophic idea it may contain. Perhaps this tolerance may be attributed to a more firmly established self-confidence in American society, both in its traditional social ideals and in its oft-demonstrated willingness to criticize and correct itself. Such an attitude might also be traced to a social

condition in which the maintenance of world order seems threatened less by conflicting political ideologies than by potentially disastrous scientific "advances."

It is particularly appropriate that the Montgomery Museum of Fine Arts undertake this project, given the significant role played by nearby Auburn University in the final stages of the original exhibition's history. When the show was disbanded in 1948, all the paintings were consigned to the War Assets Administration for public sale, and priority was given to the bids of state-supported, non-profit institutions. News of this procedure came to the attention of Frank W. Applebee, head of the Department of Applied Art at Auburn (then called the Alabama Polytechnic Institute), who became anxious to secure the paintings for the university gallery. To this purpose he enlisted the help of Ralph B. Draughon, acting president of Auburn. Sharing Applebee's enthusiasm for the purchase, Draughon contacted Alabama's U.S. congressman George Andrews and U.S. senators John Sparkman and Lister Hill, all of whom endorsed the proposed acquisition. Comprehending the importance of the show, these men desired to purchase the collection in its entirety; however, regulations dictated that separate bids

had to be submitted for each painting. By this method, Auburn was able to acquire thirty-six works of art, the largest group of paintings procured by a single institution. Ignoring attacks in the local press, and steadfastly refusing offers for purchase by private collectors, these men were unusually foresighted in recognizing the aesthetic worth and historic significance of the paintings they had acquired; an expression of praise and thanks is due them.

A project of this type and magnitude depends upon the good will and cooperation of a great many people, and the Montgomery Museum of Fine Arts has been extremely fortunate in the help it has received from a number of institutions and individuals. For generous financial aid we thank the National Endowment for the Arts, particularly Andrew Oliver, chairman of Special Exhibitions, and Larry Rickard, Conservation Division. For support of educational programs connected with the exhibition we thank the Committee for the Humanities in Alabama, Walter Cox, chairman, and the Alabama State Council on the Arts and Humanities, M. S. Zakrzewski, executive director. Significant aid was also supplied by Auburn University, Dr. W. S. Bailey, interim president, and by the Blount Foundation, Duncan J. McInnes, president.

For their participation in the tour of the exhibition I wish to thank directors Paul Rovetti, William Benton Museum of Art; Charles Eldridge and Henry Lowe, National Museum of American Art, Smithsonian Institution; and Ronald McKnight Melvin, Terra Museum of American Art. As curator of the exhibition and author of one of the catalogue's two essays, Margaret Lynne Ausfeld, acting curator at the Montgomery Museum of Fine Arts is to be commended for her achievement, as is Virginia M. Mecklenburg, associate curator of contemporary art, National Museum of American Art, who also contributed an excellent essay to the catalogue. Finally, for their enthusiastic support of the Montgomery Museum of Fine Arts, I wish to thank the Honorable Emory Folmar, mayor of the city of Montgomery, and his staff, and the Montgomery County Commission, Mack McWhorter, chairman. The support of these governmental bodies is essential to the well-being of the Museum, and we are grateful for their encouragement and sustained interest in our programs.

Ross C. Anderson
Director
Montgomery Museum of Fine Arts

Acknowledgments

The reassembly of a preexisting art exhibition, which under some circumstances could prove a lackluster undertaking, was in the case of *Advancing American Art* a stimulating challenge. The opportunity to examine American paintings of the 1930s and 1940s in their contemporary context, and to tell the astonishing story of the collection's history, inspired the generous cooperation of many individuals.

The chance to reconstruct the exhibition was made possible in large part by Auburn University's commitment of funds and loan of art works. Taylor Littleton, dean of academic affairs; Charles Hiers, chairman of the Art Department; and Mark Price, curator of the Auburn collection have provided their aid in seeing this project to completion. Former curator of the Montgomery Museum of Fine Arts, Mitchell Douglas Kahan, was instrumental in beginning the work; he recognized immediately the significance of the Auburn paintings when he first saw them in late 1979. The following persons offered their help in the task of locating other paintings from *Advancing American Art:* May Fitzgerald, librarian, Whitney Museum of American Art; Cynthia Siebels, librarian, Kennedy Galleries; Marla Price, Washington, D.C.; Michael Preble, curator of collections, Portland Museum of Art; Mona Hadler, New York City; Susan Cooke, research assistant, Whitney Museum of American Art; and John Crocket, former arts advisor for the U.S. Information Agency.

Assistance in tracing the history of the exhibition and obtaining original source materials was provided by Sally Marks, archivist, National Archives;

Martha Davidson, Pacific Palisades, California; Ruth Heindel, Harrisburg, Pennsylvania; Professor Frank Ninkovich, St. John's University, New York City; Professor Richard McKeon, University of Chicago; Ken Craven, research associate, Humanities Research Center, University of Texas at Austin; and Julia Rutledge, Gwendolyn Kay Norris, and Tommy Anderson of the Montgomery County, Alabama, Library Reference Department.

The present owners of paintings from the *Advancing American Art* collection have been most cooperative in providing documentation and photographs of these works. Particular thanks are due to Edwin J. Deighton, assistant director of the Museum of Art at the University of Oklahoma, who gathered exhaustive data on the thirty-six works now in that museum and who was instrumental in arranging for the loan of those paintings housed there. To those other lending institutions, thanks go to Chris Bruce, manager of exhibitions and collections, Henry Art Gallery, University of Washington; Patricia Poyma, art advisor, U.S. Information Agency; Robert Johnston, registrar, National Museum of American Art; Linda Steigleder, registrar, Georgia Museum of Art; Sanna Deutsch, registrar, Honolulu Academy of Art; Marilyn P. Tatrai, art registrar, The Jane Voorhees Zimmerli Art Museum, Rutgers University; Elizabeth H. Altman, education director, Washington County Museum, Hagerstown, Maryland; Duane G. Fiocca, director of operations, and Roy William, district representative, Owego Apalachin Central School District; John Semeniak, superintendent of schools, New York Mills Union Free School District; Lynn Duenow, New Trier

Township High School; and Charles I. Kent, president, Lancaster Art Association, Lancaster, Maryland.

The staff of the Montgomery Museum of Fine Arts has given indispensable advice, encouragement, and assistance during the course of this project. The details of registration were largely undertaken by Assistant Director C. Reynolds Brown, who also completed arrangements for the conservation of the paintings from the Auburn collection. Education Curator Mary Sater Ward and Assistant Education Curator Frances Sommers have made valuable suggestions for the education programs connected with the exhibition and have handled many of the arrangements. Typists Sarah Thiemonge and Peggy Powell expertly prepared the catalogue copy for publication, and Elizabeth J. Samuels assisted with copyediting and proofreading. I am especially grateful to Acting Assistant Curator Lyn Ross McDonald, who compiled the extensive bibliography and catalogue of the exhibition with the utmost attention to scholarship, and to Mitchell Kahan who offered important suggestions for my essay. Montgomery Museum of Fine Arts Director Ross C. Anderson has reviewed each aspect of the *Advancing American Art* project and his contributions have assured a presentation of the highest quality.

Finally, I would like to thank each of the lenders, whose generous loans of art work have made this exhibition a reality.

Margaret Lynne Ausfeld
Acting Curator
Montgomery Museum of Fine Arts

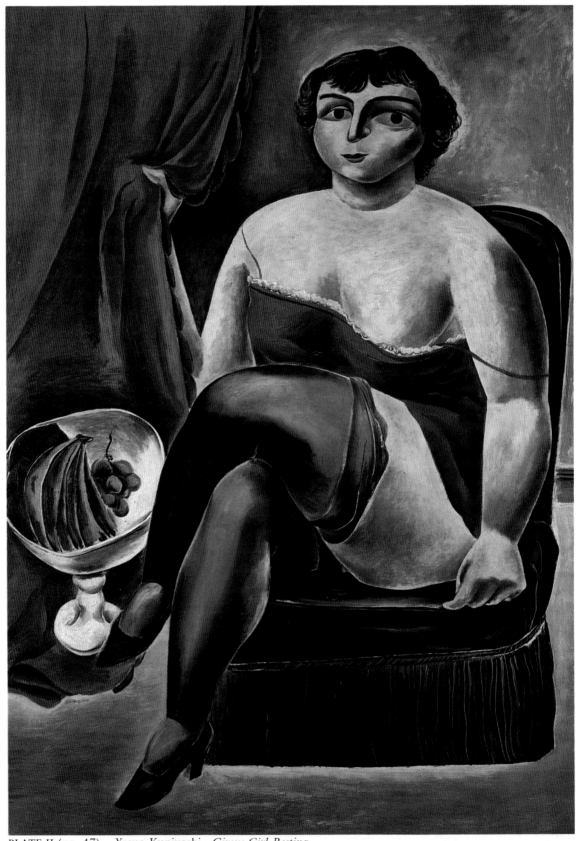

PLATE II (no. 47) Yasuo Kuniyoshi *Circus Girl Resting*

by Margaret Lynne Ausfeld

Circus Girl Arrested

A History of the *Advancing American Art* Collection, 1946-1948

The pictures make a beautiful show, vital, imaginative, representative of the most progressive trends in American art today. But I've a notion some of the stuffier gentlemen in Congress, the ones who haven't been to an art exhibition since their school days and consequently know all about art, won't like it. They'll fill the air with their lamentations for the poor taxpayer and his money. Too late now. The stuff's been bought and paid for, and by the time Congress convenes again the pictures will be overseas.

Emily Genauer, "Art for All to
See," *Ladies Home Journal,*
November 1946.

Emily Genauer, art writer for the New York *Herald Tribune,* was prophetic in her assessment of reaction to *Advancing American Art,* a collection of paintings purchased by the U.S. Department of State for overseas traveling exhibitions that began in October of 1946. The collection's title succinctly stated the goal of its organizers, State Department officials J. LeRoy Davidson and Richard Heindel, who sought to show the world the most innovative and creative contemporary art this country had to offer—what was "modern" in modern American painting. Using funds from the department's Office of International Information and Cultural Affairs, Davidson purchased seventy-nine oils and seventy-three watercolors. From this collection he intended to extract exhibitions for travel in both hemispheres during a five-year period. Among the artists chosen to participate were established, prestigious figures in the world of American art—John Marin, Georgia O'Keeffe, and Arthur Dove, for example—and others who held substantial promise for the future. Each was a standard bearer for American art's progressive and liberal trends, rather than the traditional styles that overseas audiences expected in government-sponsored art exhibitions.

Support for the project from leading segments of the American art community was immediate and generous. Many dealers and artists, honored to

find official sanction and government patronage for so innovative a project, responded by providing paintings at prices below their market value. The Metropolitan Museum in New York exhibited the seventy-nine oils of *Advancing American Art* to give press and public an opportunity to applaud the works that would soon represent America's culture abroad. A major art periodical, *Art News,* dedicated a significant portion of its October 1946 issue to reproductions of work from the collection. Most importantly to Davidson, paintings from *Advancing American Art* were chosen to represent the United States at an exhibition in Paris celebrating the opening of the first general UNESCO conference. There, in the heart of the European art world, he hoped to demonstrate that the vitality and creativity that had historically characterized American civilization was doing the same for American painting.

After its initial showing in Paris, and later successful openings in Prague, Czechoslovakia; Port-au-Prince, Haiti; and Havana, Cuba, Davidson found his expectations for the collection fulfilled. The overseas reactions were gratifying, and U.S. embassy personnel in other locations cabled their requests to exhibit *Advancing American Art* paintings. However, these requests were never to be honored. Regardless of foreign enthusiasm for the show, *Advancing American Art* soon became a target for

criticism from a less sympathetic American public. During the exhibition's tour, nationally distributed periodicals such as *Look* magazine and syndicated newspapers carried articles that severely attacked the show, judging the paintings to be vulgar, ugly, and a waste of taxpayers' money. To substantiate the authors' harsh opinions, many works were reproduced, often with derogatory captions.

Worst of all, and most significantly in the political climate of the time, the paintings were denounced for perceived leftist radicalism of the artists who painted them. The virulent, frequently irrational criticism engendered by the exhibition was rooted in the fear of communist subversion and the unlikely theory that modern art, especially abstraction, could be equated with communist ideology. For a few months in 1947 Americans, en masse, became art critics. Incited by the sarcastic press accounts of tax money for "junk" art, they wrote letters to Washington demanding the exhibition's recall. The public's commitment to "Americanism" in art, and their antagonism toward that which they regarded as "foreign," were powerful forces that ultimately led the State Department to repudiate *Advancing American Art.*

Fearing that congressional ire over the art controversy would jeopardize the funding of other international information programs, Davidson's and Heindel's supervisor William Benton, assistant secretary of state for public affairs, and Gen. George C. Marshall, secretary of state, cancelled the exhibition in early 1947. They dismissed Davidson and ignominiously abandoned the paintings, later selling them off as war surplus property. Tangible evidence of the collection's existence was thereby disposed of and the files closed in an episode the State Department regarded as unfortunate and best forgotten. Thus did a once-heralded, innovative exhibition find its place in the footnotes of American art history.[1]

It was a long-standing, cavalier attitude on the part of European intellectuals, one which branded the United States a cultural wasteland, that was responsible for *Advancing American Art* and other U.S. cultural programs for overseas audiences. Prior to the establishment of the Division of Cultural Affairs in 1938, there was strong resistance within the State Department to "official culture," a concept which seemed inherently undemocratic and suspiciously reminiscent of European artistic elitism.[2] The State Department had left the creation of cultural programs for overseas consumption largely to the private sector, with occasional official participation through contracting agencies such as the American Federation of Arts, the Council for Inter-American Cooperation, and most notably the National Gallery of Art. During the Second World War, the official mobilization of the arts was deemed advisable by the State Department to counter Nazi propaganda, which reiterated the charges that the United States was a solely militaristic, technological society.[3] Culture thus became an established instrument of American foreign policy with the creation of such bureaucratic clearinghouses as the Office of the Coordinator of Inter-American Affairs in 1940 and the Office of War Information in 1942.

These two agencies, which were responsible during the war years for projecting a positive U.S. image in Latin America and Europe respectively, incorporated cultural components into a broad program that disseminated general information on American life and society. At the close of hostilities, the State Department absorbed the functions and personnel of these agencies into its regular hierachy, in the process assuming a higher profile and greater direct involvement in information programs. America's pre-eminent position in world affairs after the war found a natural extension in the cultural sphere, and the continuation of the wartime programs was substituted for the laissez-faire policy of 1938. As of January

1946, art programs were housed in the Office of International Information and Cultural Affairs, which fell under the jurisdiction of Assistant Secretary of State for Public Affairs William Benton.

The exhibitions for which the State Department contracted prior to 1946 were often organized by such respected institutions as the National Gallery of Art, whose Inter-American Office developed collections to tour Latin America under State Department auspices. With few exceptions, these exhibitions were composed of art work that the broadest segment of the American public would find accessible and unobjectionable.[4] Within this context, Americans generally divided contemporary art into two camps—the representational which was "American" and the abstract which was "foreign."[5] Because the general public had no understanding of the intellectual theories of historical European art movements upon which abstraction was based, the most widely accepted painting (such as that of the Regionalist or American Scene traditions) tended to be easily apprehensible and non-European in derivation.

Many in the American art community, on the other hand, held no such prejudices about either abstraction or other European-influenced painting, and they marked with interest and excitement the development of a formalist school in American art. In their eyes, abstract and expressionist art were true products of American intellectual development and creativity, which would someday rival the best European painting. One person who took this viewpoint was J. LeRoy Davidson, the Harvard-educated former assistant director of the Walker Art Center in Minneapolis, who as a wartime Army employee was transferred to the State Department in 1945 to guide its fledgling art program. Visual Art Specialist Davidson and his immediate supervisor

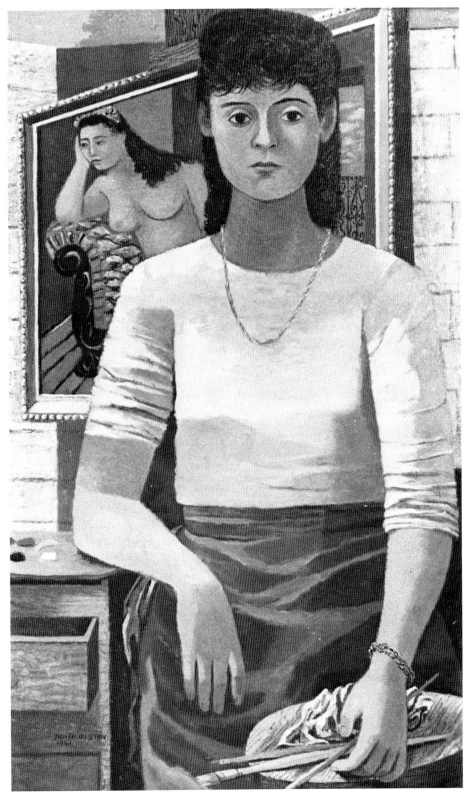

FIG. 1 (no. 37) Philip Guston *Portrait of Shannah,* 1947

Richard Heindel, chief of the State Department's Division of Libraries and Institutes, were the two officials most responsible for the contracted art exhibitions, and they both felt strong discontent with the type of exhibitions that the National Gallery was providing. Their conclusion was that the shows organized by the gallery were too conservative aesthetically and too often composed of European art in American

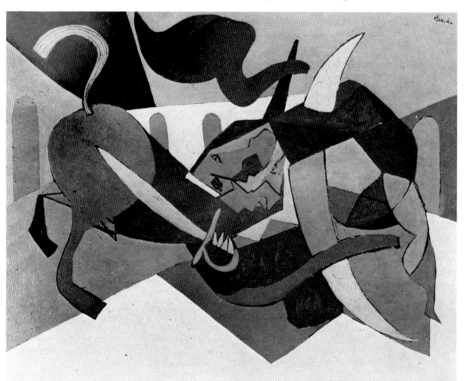

FIG. 2 (no. 4) Romare Bearden *At Five in the Afternoon*, 1946

collections. They believed these exhibitions were doing nothing to promote American art. In the meantime, Davidson and Heindel had purchased small groups of contemporary American prints for the division to circulate overseas. Embassy personnel were so enthusiastic in their reception of these, that Davidson and Heindel felt an exhibition of paintings, organized on the same lines, would also prove successful.[6]

The executive order transferring personnel and unexpended appropriations from the Office of War Information and the Office of the Coordinator of Inter-

American Affairs to the State Department also encompassed the employees and funds of the Division of Libraries and Institutes. In the newly created Office of International Information and Cultural Affairs, Davidson and Heindel thus were presented with the funds and opportunity to develop the exhibition they had discussed as an alternative to the National Gallery shows. This exhibition was to counterbalance the conservative orientation of the Gallery's exhibitions, presenting a group of works by the most progressive American painters of the time. It was intended to demonstrate to the European art community how far the United States had come as an innovative force in contemporary painting. In preparing the exhibition themselves, Davidson and Heindel took the important step of placing responsibility for the selection of art work directly with the State Department, rather than investing it in an outside art authority such as the National Gallery. It was also Davidson's decision to purchase, rather than to borrow the paintings, that would later prove disastrous to *Advancing American Art*.

Davidson's reasons behind the decision to purchase were several. Loans of art for overseas travel are traditionally difficult to obtain for extended periods and expensive to underwrite for short ones. Thus borrowed exhibitions might be seen in only one or two large cities during a year's period despite great worldwide demand for them. Having purchased contemporary prints to send abroad, Davidson was aware that government ownership presented advantages that made such an investment attractive. When owned by the State Department, the works could be self-insured by the government with both packing methods and shipping schedules handled at government discretion. After the exhibition's indefinite travel, the works could be placed in embassies or other overseas cultural centers and libraries run by the same division of the

department, thus saving the expense of sending them back to the United States. Davidson's own connections with New York dealers made the purchasing scheme practical; his previous position at the Walker Art Center had placed him in contact with many sources for contemporary art.[7]

While purchase of the works was logically defensible on several counts, Davidson's method for selecting the art was subjective. As if a curator in a museum setting, he took sole responsibility for determining which artists and works to include in the exhibition. He rejected a jury system, which would have been safer politically but might have included less innovative works, and instead consulted privately with a small number of professionals familiar with the contemporary art scene.[8] Taking their suggestions into consideration, he went to dozens of galleries (among them the Downtown Gallery, Samuel Kootz, Kraushaar, ACA, Associated American Artists, and Alfred Steiglitz's An American Place), frequently appealing to the dealers' patriotic spirit to obtain paintings at a significant discount.[9] In this way, during the spring and summer of 1946, he amassed a total of seventy-nine oils for less than $49,000. This limited budget made it impossible to obtain major works by artists as successful as O'Keeffe, Marin or Dove, however the overall quality and variety were remarkably high. Two smaller collections of watercolors were purchased by the American Federation of Arts under a contract to supplement the oils.[10]

Advancing American Art, as the collection came to be titled, was introduced at the Metropolitan Museum during a three-week period in October of 1946. The issue of *Art News* for that month was devoted to the exhibition, reproducing twenty-two of the works with an article by editor Alfred Frankfurter. Confident of the support from his prominent friends in the art world who had provided their enthusiastic co-operation, Davidson was anxious to garner wide exposure and press for the paintings before sending them overseas.[11]

Critical reaction to the seventy-nine oils shown in New York was generally favorable, especially toward the exhibition's purpose and concept. Ralph M. Pearson wrote in *Art Digest* that "it is well for us to join the family of nations on a more adult level the balance [of the paintings] are a cultural asset. They are 'advancing American art' with practically no direct reflection of Paris. This exhibit vindicates the one-man jury system."[12] A young Clement Greenberg writing in the *Nation* called the exhibition "the best group show of this nature to be held in New York for years." He praised Davidson's concept, "in which there is some relationship to be discerned between the bad and the good; they are not thrown together helter-skelter by a jury whose only connection between members is one of time and place; they have an organic relation to each other that is enlightening in itself."[13]

Writing in *Art Digest,* Jo Gibbs expressed the reservations of other critics when she observed that "too many of our better known painters are represented by short of their best work, or even untypical examples. Some of the works are near twenty years old, others so topical in subject that they will have lost much meaning within even the period of the tour."[14] *New York Times* art critic, Edward Alden Jewell, summarized the reactions: "Not all the artists are represented by anything like their best work . . . but by and large Mr. Davidson has spent the State Department's money advantageously."[15] After closing at the Metropolitan on October 27, 1946, the exhibition was, as planned, divided into two sections: one for Latin America, the other for Europe. Thirty of the oils were sent first to Cuba, then to Port-au-Prince, Haiti. A second group of forty-nine oils and thirty-five watercolors was displayed at

Its objective is to show the creative side of American painting, not a cross-section. It is planned frankly to appeal to the informed opinion in each country rather than to the multitude.

Ralph M. Pearson, "Modern Viewpoint," *Art Digest,* October 15, 1946.

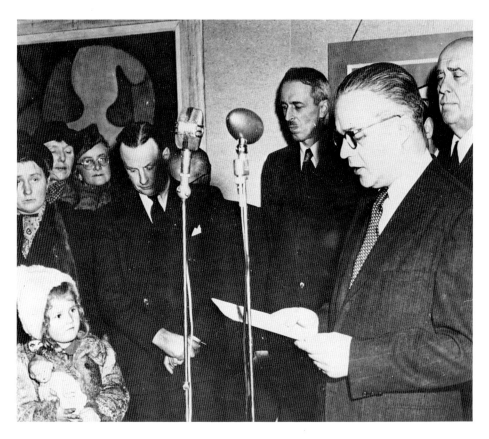

FIG. 3
Dr. Vladimir Novotny, director of the Czech National Gallery, delivers an address at the opening of the *Advancing American Art* exhibition in Prague, Czechoslovakia, March 6, 1947. In the background are William Baziotes' *Flower Head* and Ralston Crawford's *Plane Production.* Photograph courtesy of Ruth Heindel.

the Musée d'Art Moderne in Paris as the American contribution to the festivities surrounding the first general conference of UNESCO. The reaction in Paris, Davidson felt, would be the true measure of the program's success.

Although Davidson sought the approval of the Parisian art community, such approbation was highly unlikely in light of the previous reception for American art there. While admiring Americans' industry and business acumen, Europeans clung fiercely to the belief that the fine arts found little favor in the United States—a nation of technocrats rather than artists. An early attempt to dispel this perception was a survey of American painting sent by the Museum of Modern Art to the Jeu de Paume in Paris in 1938. It did not do much for the reputation of American artists, however. Critic Jean-José Marchard remembered it ten years later as a significant event in the cultural history of Paris but characterized it as "the result of two centuries of study: medi-

ocre imitations, with not a single real personality."[16] World War II had the effect of stifling most such exchanges, while at the same time U.S. military success and the influx of Americans created great curiosity regarding American culture in general.

In reviewing the *Advancing American Art* paintings brought to France eight years later, the French art weekly *Les Arts,* in its issue of November 22, 1946, observed the emphasis on modernism that characterized the contributions of many nations in the UNESCO exhibits: Other nations "concentrated their efforts on singling out the most recent trends, and that has permitted England and the United States to give their painting a vigorous aspect which has very successfully changed the summary idea which has been generally held. . . ." Taissa Kellman, correspondent for *Art Digest,* also reviewed the exhibition. "The American section," she wrote, "was extremely exhilarating for its clarity and

vigor." However she made no attempt to claim for it any independence from the French tradition: "The largest section of the show was natuarally dominated by the School of Paris."[17]

When the exhibition closed in Paris on December 20, 1946, the oil paintings were shipped to Prague, Czechoslovakia, (not yet a part of the Soviet bloc)[18] for the first stop on a scheduled five-year tour. The exhibition was officially opened on March 6 by the information minister, Jan Masaryk, with more than one thousand guests in attendance. (Fig. 3) It was an instant popular success, with more than eight thousand persons attending the twenty-day showing. The Czech government, which had taken over the financial responsibility for local expenses, also provided a small guide to the exhibition in Czech in response to widespread demand for information about the paintings and artists. The president of Czechoslovakia, Eduard Beneš, visited the exhibition on March 25—a visit that was expected to be purely ceremonial but lasted more than an hour and a half. The president studied the paintings carefully and welcomed the program as evidence of U.S. interest in closer cooperation with Europe.[19] The exhibition went on to be seen in Brno from March 29 to April 13 and in Bratislava from April 18 to May 2. It was viewed by more than seventeen thousand persons during its two-month stay in Czechoslovakia. The success of the show engendered an immediate response from the Soviet government. *The Soviet Exhibition of the Works of National Artists,* a selection of government-approved "state art," opened in Czechoslovakia in early April of 1947. To encourage popular participation, airplanes flew over Prague dropping admission tickets. While the Soviet exhibition was well attended, it was reviewed very poorly. A writer for the Czech newspaper *Lidova Demokracie* commented, "The exhibition is above all an event of political significance the exhibited works are more remarkable for their physical size than for artistic value."[20]

The enthusiasm with which *Advancing American Art* was greeted in Czechoslovakia (the Latin American segment was similarly well received) was in marked contrast to the furor that surrounded the paintings at home. Attacks in the popular press, which had begun shortly after the exhibition's opening at the Metropolitan, became more numerous and derogatory after the *Look* exposé of February 18, 1947. Even as the exhibition opened in Prague, the crisis over the collection's future was reaching its final stages at home.

What began as somewhat low-key sniping at the project by groups of conservative artists turned into a full-blown field day for the conservative press, politicians, and outraged citizenry. Inevitably, the one-man jury concept was a source of controversy in the eyes of those artists not chosen to participate. On November 6, 1947, a formal complaint was sent to the secretary of state by the American Artists Professional League (AAPL), which had enlisted the support of other conservative artists' groups (such as the National Academy of Design, the Salmagundi Club, and the Society of Illustrators) in organizing a letter-writing campaign. League Vice-President Albert T. Reid observed that the artist-members of his organization "viewed with uneasiness and misgiving the one-sided selections of works which are presumed to represent and reflect our art to other nations our associated groups question the cultural value of any exhibition which is so strongly marked with the radicalism of the new trends of European art. This is not indigenous to our soil."[21]

These reactionary sentiments were quickly seized upon by the syndicated Hearst press, a group of thirty-six newspapers published in major U.S. cities by arch-conservative William Randolph Hearst. Their initial published broadside had actually occurred as early as

When I looked at some of the pictures in 'Look' I thought of Justice Holmes' remark at the burlesque show, "Thank God I am a man of low tastes."

Letter from Undersecretary of State Dean Acheson to U.S. Senator Walter F. George of Georgia, February 25, 1947.

Debunking State Department's Art

PEACE IS WONDERFUL . . . This one by Walt Kuhn, "Still Life with Red Bananas," gives us a chance to relax before continuing forward and downward in pursuit of the meaning, if any, of modern art.

YOU would think that the State Department, in arranging a world-tour of what it considers the best in modern American painting, would include work of solid, recognized artists as well as that of a lunatic fringe.

You would think that the $43,000 State Department collection, now being shown jointly in Paris and Latin America, would have at least one painting of so outstanding and internationally famous an artist as Eugene Edward Speicher.

But no. The State Department collection, as gathered by L. Leroy Davidson, of the department's Office of International Information and Cultural Affairs, concentrates with biased frenzy on what is incomprehensible, ugly, or absurd.

Thirty-eight of Speicher's paintings hang in the most famous museums of the United States, and numerous others are choice private collectors' items. He has received more prizes than he can remember.

And in keeping with his stature, he was temperate in his suggestions.

"Why not," he asked, "show vital, representative American painters?

"Why not show Europe—if you are going to show Europe anything—what representative American painting actually is, instead of just one side of it, one tendency of it."

One of the balmier aspects of modern art is abstraction, a term, which like most art jargon, is vague and wide enough to cover a variety of inanities, but which is based on what is known as synthesis, or mental images, to expose the "soul" of an object.

Of this aspect, Speicher commented mildly:

"Abstraction is in every great work of art; but it is the skeleton around which warmth and color and beauty are added. Modern art, that is, the phase of it you are talking about, insists of showing just the skeleton, which belongs in the classroom, not in a gallery."

And so, instead of one Speicher, the State Department collection has for example three paintings by Everett Spruce, who seems to belong to that school which tries to show the "treeness" of a tree, the "fishness" of a fish, or in Spruce's case, the "turkeyness" of a turkey. The result, in the Broadway sense, is indeed a turkey.

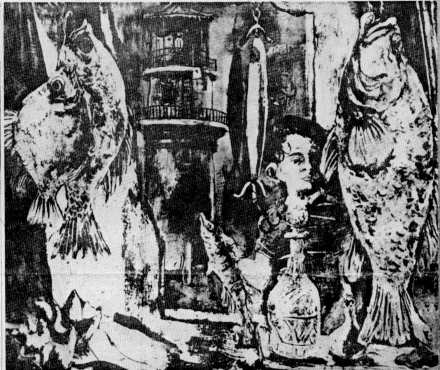

SHEER LOVELINESS . . . Is there anything more beautiful than a dead fish? Of course there is: Two dead fish, for example, or three or five. That is what makes this painting, "Around the Lighthouse," by Karl Zerbe, so wonderful. You get five dead fish. And so did the State Department!

NON-REALITY . . . The idea in modern art is to get away from reality, because everyone can understand reality, but only the modern artist can understand non-reality and that makes him something special. This State Department treasure is "The Ravine," by Joseph DeMartini.

 GIVING US THE BIRD . . . This is a t-u-r-k-e-y. A t-u-r-k-e-y is a b-i-r-d. It is an impressionist turkey, by Everett Spruce, an abstract turkey, maybe, or even a cubistic turkey. It is not good eating. Is it good painting? The State Department says, yes.

LUNATIC'S DELIGHT → . . . This thing is one of the things for which the Office of Cultural Affairs of the State Department paid $43,000 and is to be displayed in world capitals as representative of the best in American art. It is called "Perpetual Destroyer," and is by Ben-Zion.

Additional paintings will be reproduced soon in this newspaper.

October 4, 1946, the day the *Advancing American Art* collection opened at the Metropolitan. In a brief article, Howard Rushmore focused solely on the leftist political affiliations of some artists included in the exhibition, making no comment on the artistic merits of the paintings themselves.[22] The complaints by conservative artists against the "radicalism" of the exhibition and its nonrepresentational art, however, raised for the Hearst press, an issue designed to incite the broadest possible public outcry. The papers' most effective tool was devastating ridicule.

The centerpiece of the Hearst exposé was a series of three articles "debunking" modern art that were published November 19, November 26, and December 3, 1946. Each filled an entire page with reproductions of works from the exhibition (of such poor quality as to make them appear garish) with brief sarcastic commentary beneath each work. (Fig. 4) For example, O. Louis Guglielmi's painting *Tenements* (Fig. 5) bore the legend "If you contemplate adding to the suicide rate, we recommend this picture for the guest room. . . . A modern artist doesn't paint what he sees, but what he thinks he ought to see before he sees it."[23]

The accompanying articles, which incorporated the conservative views of artists referred to as "reputable,"[24] were written by staff writers whose intent was to inflame the passions of readers made hostile by the reproductions.

According to one such article, the paintings were "not American at all. The roots of the State Department collection. . . . are not in America—but in the alien cultures, ideas, philosophies and sickness of Europe. Those paintings that try to tell a story at all, give the impression that America is a drab, ugly place, filled with drab, ugly people. They are definitely leftish paintings, and it is not surprising to find that among the artists represented are eight who are, or were, members of the United American Artists, which

has consistently followed the Communist line."[25] The attacks typically displayed little knowledge of art and regarded nonobjective art as decadent. The fact that public money had been expended to purchase such works further angered conservatives.

Although damaging, the Hearst articles did not reach nearly so large an audience as one two-page spread in the *Look* magazine of February 18, 1947. *Look* reproduced seven of the works with a loaded caption "Your Money Bought These Paintings." (Fig. 6) Among the *Look* reproductions was Yasuo Kuniyoshi's *Circus Girl Resting,* a painting that came to symbolize the exhibition in the minds of the American public. The image accompanied many of the articles that were published as the controversy developed.[26] *Circus Girl* (Pl. 2), the collection's only semi-nude work, inspired the imagination of the press, which proclaimed her "something between Primo Carnera taking an enforced siesta and the product of an Easter Islander after a bad night"[27] and "a Chicago Bears tackle taking it easy during a time out."[28] Congressmen objected to "any inference that the typical American girl is better equipped to move a piano than play one."[29] Simultaneously with coverage in *Look,* Mutual Broadcasting commentator Fulton Lewis, Jr., addressed the issue in his popular radio program. On February 5 he referred to the exhibition's paintings as "excellent examples of the very worst and most terrible phase of WPA art project junk in its very worst manifestation. They're grotesque, disproportionate, totally artless and in some cases downright vulgar. . . . "If that be American art," he concluded, "God save us." On his program of February 6, he repeated the charges that the art project was a waste of public funds. Regarding LeRoy Davidson's observation that the works were not meant to be representative of American contemporary art as a whole, but only its more advanced trends,

FIG. 4
The Hearst press published three articles "exposing" the paintings of *Advancing American Art* as work of "the lunatic fringe." Poor quality reproductions and sarcastic captions combined to present the paintings in the worst possible light and assure hostile public reception. Photograph courtesy of the Humanities Research Center, University of Texas at Austin.

20

FIG. 5 (no. 36)
O. Louis Guglielmi
Tenements, 1939

Lewis reacted by telling his audience that "it [the art in the exhibitions] is so far advanced that it's completely out of sight and no one in his sane mind is ever going to try and catch up with it."[30] Predictable public reaction followed in letters that poured into the Congress and State Department. With reference to the *Look* reproductions, among them Ben Shahn's *Hunger,* (Pl. 3) a depiction of an emaciated boy with his arm upraised in supplication, one irate citizen wrote:

My vocabulary is inadequate to express the disgust and contempt I feel toward the persons responsible for wasting money in the way described on page 80 of the Feb. 18 Look Mag. We see only 7 samples of that art, but judging by that group, the whole collection isn't worth the canvas they are painted on. . . . I do not pretend to know

anything about art, but I do know there is nothing in that group of pictures to raise America in anyone's estimation. . . . We put up that tax money. . . . Well I say dump such art in the ocean, the fire or somewhere and send potatoes abroad to starving Europe. That will stop hunger instead of remind them of it.[31]

In another letter, the fear and distrust of "alien" cultural influences instilled by the Hearst articles also surfaced: "The names of the artists—Shahn, Zerbe, Prestopino, Kuniyoshi, Guglielmi do not seem to have the flavor of an American background but bring visions of a transplanted European hodgepodge at its worst."[32]

To the State Department's great embarrassment and political misfortune, no citizen was more vocally opposed to modern art than President Harry S. Truman. Truman referred to *Advancing American Art*'s abstractions as products of the "ham and eggs" school of painting, and his caustic, cynical remarks on the subject made excellent copy. When a reporter at a press conference held up for the president's comment a reproduction of the then ubiquitous *Circus Girl Resting,* he elicited the most widely quoted remark of the scandal. Truman's opinion was that the painting represented "a fat, seminude circus girl" and that "the artist must have stood off from the canvas and thrown paint at it. . . . if that's art" he added, "I'm a Hottentot." In letters the president wrote to Assistant Secretary of State William Benton on the subject of *Advancing American Art* (one of which was leaked to Drew Pearson and printed in his "Washington Merry-Go-Round" column, further fueling the fire), Truman betrayed a deep and more serious fear that modern art was symptomatic of some serious malady affecting American society:

I am of the opinion that so-called modern art is merely the vaporings

MOTHER AND CHILD
By Nahum Tschacbasov

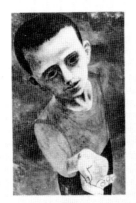

HUNGER
By Ben Shahn

THE NEWSPAPER
By Gregorio Prestopino

WORK SONG
By Robert Gwathmey

TENEMENTS
By O. Louis Guglielmi

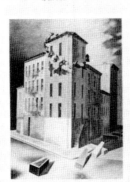

CLOWN AND ASS
By Karl Zerbe

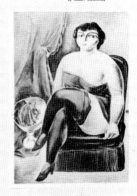

CIRCUS GIRL RESTING
By Yasuo Kuniyoshi

Your Money Bought These Paintings

They are part of a collection of modern American art purchased by the State Department for exhibition abroad

The paintings reproduced on these pages are from the State Department's new collection of modern American art. They were bought with public funds. The reason, according to the State Department, was to give people abroad a better understanding of the United States. The 79 paintings in the collection will never be shown in America. Instead, they'll go on a long tour of European and Latin American cities. After this tour is over, the paintings will be distributed to various missions abroad which the State Department maintains.

American art has been shown abroad before. But the majority of it has been the conservative type which is popular in the U. S. today. Europe and Latin America said that they wanted to see the new developments in American art. For our modern artists use symbolism, trick perspective and bold color to express themselves. Through the State Department's purchase of these paintings, the people abroad will learn about a new kind of American art.

of half-baked lazy people. An artistic production is one which shows infinite ability for taking pains and if any of these so-called modern paintings show any such infinite ability I am very much mistaken. Until we get back to the idea that the job and its accomplishment is more important than the pay, we will continue to have half-baked artists and half-efficient people in every other line of work.[33]

Republicans in Congress were especially happy to take advantage of the Democratic administration's embarrassment over the issue. The Republican National committee began its campaign in August of 1947 with an article in the *Republican News* about the exhibition.[34] (Fig. 7) Like the Hearst and *Look* pieces, it reproduced works from the exhibition with captions such as "CIRCUS GIRL RESTING by Yasuo

Kuniyoshi who, a House Committee reports, was a sponsor in 1939 of the Refugee Scholarship Peace Campaign, a communist front drive." An abstract painting by Werner Drewes, *A Dark Thought,* had no caption; its abstract quality alone was apparently condemnation enough.

It was Assistant Secretary of State Benton who took the full brunt of the considerable political fallout resulting from the negative publicity. Benton was not a career diplomat but a successful businessman who had built an important advertising agency before becoming vice-president of the University of Chicago and chairman of the board of the company that published *Encyclopaedia Britannica*. While with Britannica, Benton had overseen the development of the company's collection of contemporary paintings, a promotional device

FIG. 6
"Your Money Bought These Paintings," *Look*, February 18, 1947. The *Advancing American Art* collection came to wide public attention with the publication of this layout in the nationally distributed magazine, *Look*. These reproductions prompted letters from irate citizens to congressmen, who in turn demanded an investigation of the State Department's art program.

It's Striking, but Is It Art or Extravagance?

The 79 contemporary American paintings which the State Department bought and sent out last November on a five-year tour of Europe and Latin America (NEWSWEEK, Oct. 14, 1946) bore little resemblance to political campaign posters, but last week the Republican National Committee was trying to make political capital of them nevertheless.

Although the department had once characterized the paintings as examples of modern American culture, to William C. Murphy, publicity director of the committee, they illustrated only the extravagance of the Truman Administration and its tolerant attitude toward Communists and fellow travelers. No art critic, Murphy knew what he didn't like, and he thought he knew what the voters wouldn't like, either. Last week, he reproduced seven of the paintings in The Republican News under the heading, "Art for Taxpayers," and of-

fered the layout to newspapers for reprint. In the previous issue of The News, Murphy had printed an entire page of pictures dealing with the Kansas City vote frauds, and 60 papers had asked for it. The Kansas City layout consisted largely of newspaper clippings on the scandal. Murphy was certain his State Department picture page had even more political appeal.

The 80th Congress already had expressed its distaste for the paintings, despite the fact that some of the nation's most famous artists were represented. Mr. Truman, who has made no secret of his dislike for all modern art, obviously was embarrassed by them, as was Secretary of State George C. Marshall. Assistant Secretary William Benton had publicly regretted spending $49,000 for them. If Murphy was right about the political value of his layout, the Administration might regret it even more.

FIG. 7
"It's Striking but is it Art or Extravagance?" *Newsweek*, August 25, 1947, reproduced "Art for Taxpayers," a layout originally published in the national newsletter of the Republican party.

The alleged art exhibition has sinister aspects. . . . Foreigners must be wondering what kind of crackpots assembled such a jumble of paintings. . . . I have seen pictures of the paintings and some of them are so weird that one cannot tell without prompting which side should be up.

U.S. Representative Fred Busbey of Illinois to the House of Representatives on May 13, 1947.

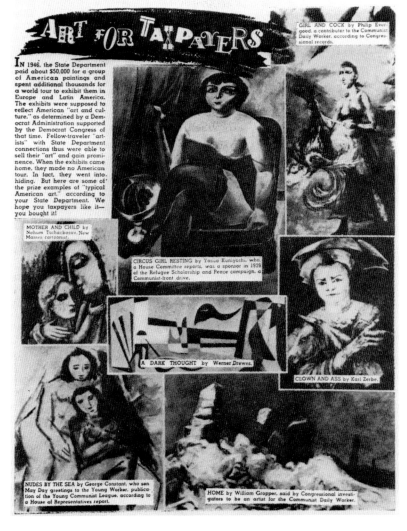

of which Benton, the former advertising man, had been quick to see the value. At the State Department, he was apparently unaware of plans for *Advancing American Art* and its actual implementation, although some publicity materials on the show were published over his name.[35] Problems in Congress with other beleaguered programs, especially the new overseas radio service, Voice of America, overshadowed what seemed initially to be an innocuous art exhibition. Benton had already faced one crisis in the appropriations hearings for the 1946-47 budget when the major radio networks and wire services, intimidated by the possibility that their overseas markets could be preempted by the Voice of America and other technologically sophisticated communications programs, had lobbied to kill his division. The publication of the *Look* article and the Lewis broadcasts presented an immediate crisis; despite Benton's numerous friends in Congress, the upcoming appropriations battle promised to be stiff. Negative publicity would severely hamper Benton's efforts to keep the information and cultural affairs services alive.[36]

With the approach of appropriations committee hearings in May 1947, the situation suddenly passed from being merely annoying to gravely serious. One of the many inquiries received by the State Department from congressmen came from John Taber of New York, chairman of the House Appropriations Committee, who called the paintings a "travesty upon art" and insinuated that no more funds would be forthcoming for art. Representative Karl Stefan, Republican from Nebraska and chairman of the House subcommittee on appropriations responsible for State Department funding, was quoted in further Hearst articles as promising an investigation of the program.[37] Increasingly, department staff members received reactions from congressmen indicating that the legislators could not justify to their constituents a vote for any art pro-

gram. The art program, wrote one staffer, "could be our Achilles' heel. Our hope . . . is that the fever will take its course. . . . "[38]

Secretary of State Gen. George C. Marshall, questioned about the exhibition while giving testimony before Congress, demanded and received from the department a memorandum explaining the exhibition. In the memorandum his staff enumerated the many requests they had received from overseas for exhibitions of contemporary art, the favorable critical responses to the current exhibit, the logic of purchasing the works, and their belief that the collection had appreciated in value since it was purchased.[39] These and other justifications were to no avail, however, as Benton learned when he heard Marshall's final opinion; "As for circus girls," the secretary remarked to a congressional committee, "that's a closed shop."[40]

Although anxious not to "sell out" his own art program, Benton was aware of the criticism in Congress that branded the State Department a haven for communist sympathizers who were believed to have entered the information services during World War II as an alternative to the armed forces.[41] After his long association with the Britannica collection, Benton was in a position to understand the trends toward abstraction in American art, and his repeatedly expressed dissatisfaction with *Advancing American Art* was not with what had been chosen but with Davidson's one-man jury system. It was consistent with Benton's background that he focused on the ways in which the collection could have been "marketed" to have made it palatable to even the most recalcitrant senator. Although he was firmly convinced that Davidson had erred in choosing the exhibition without benefit of a panel of authorities (whose reputations could be depended upon to justify the selections), this alone would not have led him to abandon the collection. His key concern was that the

Soviet Union in its political propaganda would exploit the fact that artists with known communist sympathies were included in the show.[42] This risk of serious embarrassment to the U.S. government he viewed as unacceptable, and by March of 1947 he reached the decision that the show could not be salvaged in its existing form. Benton and his staff determined several steps to calm the angry congressmen. First, although the exhibition was booked until the end of 1947, Benton ordered that the paintings be detained in Czechoslovakia and Haiti pending a verdict from a panel of "art experts" who were to determine the exhibition's fate. Second, the resignation of J. LeRoy Davidson, which had been previously offered, was accepted; his position was abolished.[43]

Benton went to the appropriations hearings prepared for a hostile reception, and he was not disappointed. Karl Stefan, chairman of the committee, baited him by holding up photographs of works from the exhibition:

Mr. Stefan: *What is this [exhibiting document]?*

Mr. Benton: *There are a great many pictures—*

Mr. Stefan: *What is this picture?*

Mr. Benton: *I can't tell you.*

Mr. Stefan: *I am putting it just about a foot from your eyes. Do you know what it is?*

Mr. Benton: *I won't even hazard a guess what the picture is Mr. Chairman.*

Mr. Stefan: *How much did you pay for it? You paid $700 for it and can't identify it.*

This process continued as Stefan held up photographs and the witness declined substantive comment.[44] Benton concluded with a statement reiterating

24

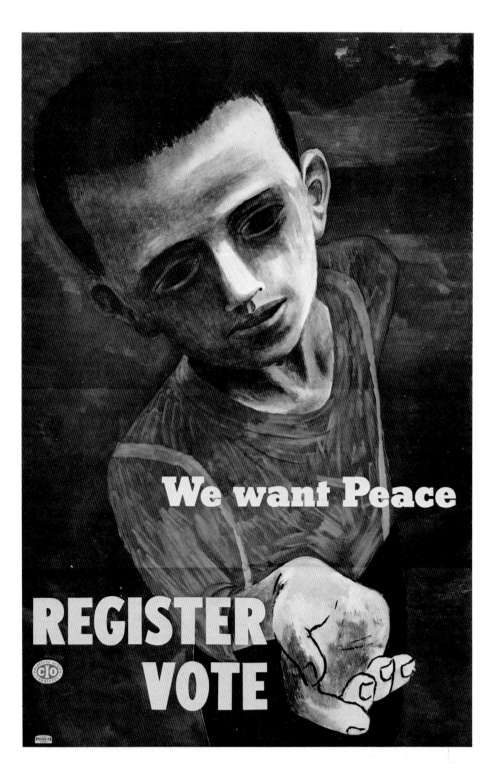

We want Peace

REGISTER
VOTE

the department's official position that art was an appropriate instrument of American foreign policy but that an error had been made in allowing one person to select the art to be shown.[45]

On May 5 the House Appropriations Committee voted to cut off funds for the art program and recommended abolishing the division. As there would apparently be no money to fund the tour of the works, the show was effectively cancelled. Outraged artists, critics, and museum professionals flooded the department with their own letters. On May 6 a meeting was held in New York to protest the exhibition's closing. Members of Artist's Equity, the Artist's League of America, and other groups with liberal political orientations sponsored speakers including James Johnson Sweeney, who had advised Davidson on the show; Juliana Force, director of the Whitney; and Edith Halpert, of the Downtown Gallery. Each deplored the State Department's decision to close the exhibition, taking note of the "wave of reaction" that characterized congressional and popular response, and prophesying "disastrous consequences" unless such censorship was rejected.[46]

Their dissent occurred too late to have any impact on the decision to recall the exhibition. In a telegram dated June 11, 1947, Secretary Marshall officially ordered the return of the works that were in Prague "in order that panel of specialists appointed to make recommendations concerning art program may review it." This expert panel never materialized.[47] The continuing attacks in Congress convinced Benton and his advisors that for the division to maintain the paintings would amount to political suicide where its other programs were concerned. They concluded that "the values involved overseas do not warrant a prolonged and intensive educational campaign here in support of it, which would involve the risk of having art symbolize

the entire program," and they determined the works should be sold.[48]

As controversy plagued the exhibition from its inception, so it continued until the end. Although wishing to dispose of the works with as little fanfare as possible, members of the art program staff fully realized that simply abandoning the works would only enhance this controversy. They anticipated protests both from the artists, whose reputations could be compromised by any ill-considered sale, and from the art community in general, already resentful toward the exhibition's demise. They hoped instead to arrange a sale of the paintings that would recover for the government a sum at least as great as the amount spent to purchase the works. However, when the department's legal counsel was called in, he advised that the State Department in essence lacked legal authority to itself sell the paintings. If all the works were to be sold, the department's only alternative was to declare them surplus property and surrender them to the War Assets Administration for disposal by auction. There was no enthusiasm for this decision on any side. Art program personnel feared more negative publicity when the term "surplus" was appended to the already much-maligned works. The War Assets Administration, normally preoccupied with the sale of heavy equipment and war material, initially balked at the request to handle the sale but eventually agreed.[49]

In order to give bidders a chance to view the works, Lloyd Goodrich at the Whitney Museum assisted in having them installed there from May 17 to June 20, 1948. The War Assets Administration followed an elaborate procedure for the sale under which different levels of priority were assigned to different categories of bidders, such as war veterans and tax-supported institutions, and under which a lottery procedure was used to choose among equal offers within the same priority band.

The 148 bidders for the collection included 16 museums and art societies, 31 educational institutions, 51 veterans, and 50 commercial (nonpriority) bidders. Priority institutions were able to enter bids to purchase works at "fair value," a price that was to be determined after the bids were opened on the basis of official appraisals and the offers of nonpriority bidders.[50] Six priority institutions (among them the American Federation of Arts and Auburn University) offered to buy every work in the collection at "fair value." After the winning bids were selected, the total price tag for the works was calculated to be $79,658, but because of a ninety-five percent discount available to most of the institutional participants, the government collected a mere $5,544 for the collection that had been officially appraised at $85,000.[51]

The two largest groups of paintings went to the University of Oklahoma and Alabama's Auburn University (thirty-six each). The remaining works were divided into smaller groups and distributed among other universities, school systems, and private individuals with veterans' preference. William Benton, who had resigned from the State Department in September 1947, bid on thirteen works; he was particularly eager to obtain Circus Girl Resting, but he was unsuccessful in his attempt to buy any of the paintings. In later years Benton regarded Advancing American Art as "the single worst mistake" of his tenure at the State Department.[52] It was unquestionably a costly mistake. Although the Congress did eventually appropriate money for information programs, it was less than half of the requested amount (10.8 out of 25 million dollars).

In retrospect, the significance of Advancing American Art lies primarily in the response that it generated. It suffered the misfortune of becoming linked in the public consciousness with sociopolitical factors only marginally

FIG. 8
We want Peace/REGISTER/VOTE. 1946. Ben Shahn's tempera Hunger was reproduced by the CIO's Political Action Committee after the painting was purchased by the State Department for the Advancing American Art collection, further angering congressmen at the Department's appropriations hearings in April 1948. Collection, The Museum of Modern Art, New York. Gift of S.S. Spivack. Photograph courtesy of the Museum of Modern Art.

So far as future Circus ladies go—that is a closed shop.

Secretary of State Gen. George
C. Marshall to Congressional
Appropriations Committee,
April 1947.

I do not like all of these artists' works, but neither do I like war, pestilence, suffering, greed and political bigotry. These are of our time, however, and I would be a fool to ignore them. Neither you, nor I, nor Congress can justly say that men cannot think, or write, or paint of any things which in their minds must be said.

Letter from D.S. Defenbacher,
director of the Walker Art
Center, to Secretary of State Gen.
George C. Marshall, April 9,
1947.

related to its purpose as an art exhibition. The controversy surrounding it was art-related only because art itself was a political topic in the 1930s and 1940s, when artists, especially those of the Social Realist School, functioned conspicuously as social critics. Davidson's and Heindel's goals in organizing the exhibition were traditional liberal democratic ones; they wished to promote international understanding while glorifying a society that allowed the production of intellectually and politically provocative art. The violence of popular reaction demonstrated how totally the public rejected these goals and revealed a mood largely conservative, isolationist, and anti-elitist. Such attitudes were not limited to the 1930s and 1940s. Criticism of *Advancing American Art* was the first small trickle of what would become in the 1950s a torrent of abuse from conservative art groups and congressmen where modern art was concerned. Supporters of modern art were continually on the defensive against congressmen such as Illinois Republican Fred Busbey, and especially, Michigan Republican George Dondero, who continued during the McCarthy era to deliver speeches vilifying modern artists, contemporary art critics, and museums as tools of communist subversion.[53]

In later years responsibility for exhibitions abroad shifted from one governmental entity to another. In 1955 the U.S. Information Agency which was handling such arrangements maintained an official policy excluding "works of avowed Communists." Other groups that took on the task were government-funded but semi-autonomous, such as the International Art Program at the Smithsonian's National Collection of Fine Arts and the International Exhibitions Committee established in 1976. Most recently, the responsibility has rested with the International Communications Agency. Each of these entities has sought to achieve a delicate balance that enables

the government to support artistic efforts without regard to content and that removes art from the tainting sphere of propaganda. The career of *Advancing American Art* demonstrates the difficulty of reconciling public taste and prejudice with artistic freedom.

NOTES

The records of the State Department Art Program 1946-48 are located within the General Records of the Department of State and the Records of the Assistant Secretary for Public Affairs 1945-1950, National Archives, Washington, D.C. Decimal file numbers refer to the General Records, while box numbers refer to the Assistant Secretary's records.

1. Two published articles have examined the *Advancing American Art* affair as a manifestation of the relationship between art and culture during the period of the late 1940s. They are Jane DeHart Mathews, "Art and Politics in Cold War America," *The American Historical Review* 81 (October 1976): 762-787, and Frank A. Ninkovich, "The Currents of Cultural Diplomacy: Art and the State Department, 1938-1947," *Diplomatic History* 1 (July 1977): 215-237. A third account is found in Gary O. Larson, *The Reluctant Patron: The United States Government and the Arts, 1943-1965* (Philadelphia: University of Pennsylvania Press, 1983).

2. Three sources for the history of cultural information programs in the U.S. State Department are Charles A. Thomson and Walter H. C. Laves, *Cultural Relations and U.S. Foreign Policy* (Bloomington: Indiana University Press, 1963); Ruth Emily McMurry and Muna Lee, *The Cultural Approach: Another Way in International Relations* (Chapel Hill: University of North Carolina Press, 1947); and most recently Frank A. Ninkovich, *The Diplomacy of Ideas: U.S. Foreign Policy and Cultural Relations, 1938-1950* (New York: Cambridge University Press, 1981).

3. Ninkovich in *The Diplomacy of Ideas* states that the problem presented in South America was "not only to prevent a pro-Nazi intellectual coup, but also to divert the traditional pro-European intellectuals into an inter-American framework." Ninkovich, *Diplomacy,* 42. See the Chapter entitled "Wartime Departures from Tradition" for a complete account of State Department reactions to Nazi influence in South America. *Ibid.*

4. Two exhibitions coordinated by Davidson and Heindel were typical of the type exhibition planned for overseas tour. They were *American Industry Sponsors Art* and *Sixty Americans Since 1800,* both surveys of American painting that incorporated "advanced" trends into a broader historical context and generated little notice outside of the art world. See Larson, *The Reluctant Patron,* 24, and Ralph Purcell, *Government and Art: A Study of the American Experience* (Washington, D.C.: Public Affairs Press, 1956). One exhibition of modern painting organized as part of the cultural relations program for Latin America had provided a prelude to the controversy over *Advancing American Art* by attracting the notice of conservative congressmen. See Ninkovich, *The Diplomacy of Ideas,* 63.

5. See Mathews, "Art and Politics," 782; Aristodimos Kaldis, "The Question of Nationalism," *Art Digest* June 1, 1943, 19; and William Hauptman, "The Suppression of Art in the McCarthy Decade," *Artforum* 12 (October 1973): 50.

6. For example, see Memorandum, L. Landry to Visual Art Specialist LeRoy Davidson, November 22, 1946, General Records of the Department of State, Records for the Assistant Secretary for Public Affairs 1945-1950, Art, Box 7, National Archives, Washington, D.C. regarding the success of an exhibition of prints in Bogota, Columbia. Curiously, some of the strongest interest in showing *Advancing American Art* came from the American embassy in Moscow. See Memorandum, Assistant Secretary of State of Public Affairs William Benton to Ambassador Smith, May 15, 1947, RG William Benton, Art, Box 7, NA, and Cable, Davidson to American Embassy, Moscow, November 5, 1946, DS 811.42700(A)/10-1846 General Records of the Department of State, Record Group 59, NA.

7. Davidson's own explanation of his methods is recounted in "Advancing American Art," *American Foreign Service Journal* 23 (December 1946): 7.

8. Davidson asked the advice of Hudson Walker, president of the American Federation of Arts; Herman More, curator of the Whitney Museum of American Art; James Johnson Sweeney, director of painting and sculpture at the Museum of Modern Art; Maude Kemper Riley, publisher and critic; and dealer Alfred Stieglitz. See Memorandum, Secretary of State George C. Marshall to Representative Karl Stefan, February 20, 1947, RG Benton, Art, Box 7, NA.

9. A listing of the oil paintings and the galleries from which they were purchased is found in the special issue of *Art News* that focused on the exhibition. See Alfred M. Frankfurter, "American Art Abroad: The State Department's Collection," *Art News* 45 (October 1946): 78. Heindel wrote to Benton on April 2, 1947, regarding discounts given by cooperative artists and dealers, saying "I believe you would find that there is about an over-all average discount of 25% on actual selling prices. . . ." See Memorandum, Chief of Division of Libraries and Institutes Richard Heindel to Benton, March 28, 1947, RG Benton, Art, Box 7, NA, regarding Benton's reply to member Fred E. Busbey of the House of Representatives. Edith Halpert, director of the Downtown Gallery, stated that the purchases cost the government "less than $600 per painting." She said that ten dealers (unnamed, but she was one) participated in the original sale and that they grossed approximately $1000 each. She is quoted in Thomas Craven, "Is American Art Degraded?" *'48* 2 (June 1948): 78.

10. One group of thirty-eight watercolors was apparently never shown overseas. They had been purchased in December 1946, later than the rest of the collection, to form an exhibition for China. The thirty-five watercolors shown as a part of *Advancing American Art* in Paris and Latin America were not sold and apparently remained within the department, dispersed to various offices. Several of these works have recently come to light in an inventory of government-owned art work being conducted by the General Services Administration. Paul Richard, "Found Art—$250,000 Worth," *Washington Post,* December 3, 1982, sec. E, p. 1. Lists of watercolors and oils purchased can be found in Art Program Report, February 21, 1947, RG Benton, Art, Box 7, NA. See also, Letter, Assistant Chief Division of Libraries and Institutes Lawrence Morris to Director of American Federation of Arts Thomas Parker, May 4, 1948, RG Benton, Art, Box 7, NA.

11. Frankfurter, "American Art Abroad." Davidson and Heindel had many prominent connections in the art world who assisted the project. Davidson's wife Martha was at one time a writer for *Art News.* Heindel was a "close friend" of Francis Henry Taylor, director of the Metropolitan Museum. See Memorandum, Heindel to Benton, October 6, 1946, RG Benton, Art, Box 7, NA on the opening at the Metropolitan Museum. Many of those Davidson consulted regarding artists to include in the show, and of those who wrote letters of protest when it was cancelled, were members of the board of the American Federation of Arts, an agency that routinely received grants from the State Department to produce exhibitions under contract.

FIG. 9 (no. 3) Gifford Beal *Figures*

12. Ralph M. Pearson, "State Department Exhibition for Foreign Tour," *Art Digest* 21 (October 15, 1946): 29.

13. Clement Greenberg, "Art," *The Nation* 163 (November 23, 1948): 594.

14. Josephine Gibbs, "State Department Shows 'Goodwill' Pictures," *Art Digest* 21 (October 1, 1946): 13, 24.

15. Edward Alden Jewell, "Eyes to the Left: Modern Painting Dominates in State Department and Pepsi-Cola Selections," *New York Times*, October 6, 1946, sec. 2, p. 8. Accounts and reviews generally evidenced a positive attitude toward progressive trends in American painting. See Frankfurter, Robert Coates' review "The Art Galleries: The Jury System and Other Problems," *The New Yorker*, October 12, 1946, 74-75; Jane Watson Crane's account "State Department Sends New Type U.S. Art Show Abroad," *Washington Post*, October 27, 1946, 7.

16. Jean-José Marchard, *Combat*, September 9, 1947, p. 12. A summary of European attitudes toward American painting can be found in Ruth Benjamin, "American Art Through Foreign Eyes," *Gazette des Beaux Arts* 25 (May 1944): 310.

17. Taissa Kellman, "Letter from Paris," *Art Digest* 21 (December 15, 1946): 18. Kellman's review did not reflect the same opinions as that of reviewers in the United States who saw greater independence of Paris in the works. The UNESCO exhibit did not attract widespread press attention; the attitude of Parisian critics toward American painting of the period can be discerned however in reviews of an exhibition *Introduction to American Painting,* contemporary works shown at the Galerie Maeght in November of 1947. Six artists from the Samuel Kootz Gallery were shown: Adolph Gottlieb, Carl Holty, Robert Motherwell, William Baziotes, Romare Bearden and Byron Browne. All, with the exception of Holty, were a part of the *Advancing American Art* show. The judgements made by the critics were uniformly condescending: "The artists are obsessed by the processes and mannerisms of the 'Paris School' " *(Lettres Françaises,* November 4, 1947); "American painting is little known in Paris. It would not seem that it has been possible to detect in it profoundly original elements which would make of it a distinctively

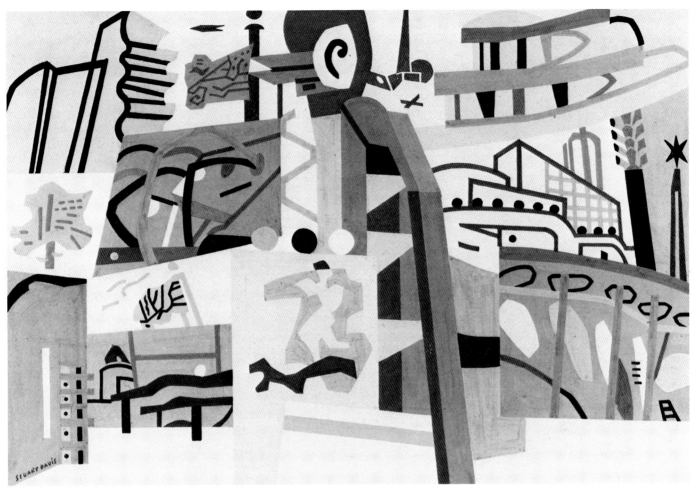

FIG. 10 (no. 17) Stuart Davis *Impression of the New York World's Fair,* 1939

American school. . . . In any case, there is no comparison possible with French Painting." *(La Figaro,* March 4, 1947); "Is [this exhibition] to demonstrate to us that abstract art has no further secrets for American artists? Or did they merely wish to prove to us that the Yankees—always on the lookout for something new—are in the forefront of modern art?" *(Arts,* April 4, 1947).

18. The Soviet Union orchestrated a coup d'etat in Czechoslovakia in February 1948, not quite one year after *Advancing American Art* had been shown there. Jan Masaryk, who had officially opened the exhibition, was by then president of the country and died at the time of the coup. See Felix Gilbert, *The End of the European Era, 1890 to Present,* 2nd ed. (New York: W. W. Norton and Company, 1947).

19. President Eduard Beneš's visit to the exhibition and its general reception in Czechoslovakia are detailed in Report, Lawrence A. Steinhardt to Marshall, May 6, 1947, DS 811.42700(A)/5647, RG 59,NA.

20. This review and excerpts from others in Czechoslovakian newspapers are included in Dispatch, American Embassy, Prague, May 9, 1947, DS 811.42700(A)/15-947, RG 59, NA.

21. The letter in its entirety is reproduced in Albert T. Reid, "League Protests to the Department of State," *Art Digest* 21 (November 15, 1946): 32.

22. Howard Rushmore, "State Dept. Backs Red Art Show," *New York Journal-American,* October 4, 1946. This attack, appearing as it did the day of the opening of the collection at the

Metropolitan, was certainly orchestrated prior to that date. The article lists eight artists suspected of harboring Communist sympathies, including William Gropper, "for years [the] editorial cartoonist for the *Daily Worker* [who] drew cartoons depicting the superiority of Stalin's foreign policy to that of the American Government's." *Ibid.*

23. "Debunking State Department's Art," *New York Journal-American,* November 19, 1946.

24. Two artists who provided quotes vilifying modern art to the *Journal-American* writers were S. J. Woolf "artist, critic and author," and Eugene Edward Speicher, identified as "outstanding and internationally famous." They are quoted in "Debunking State

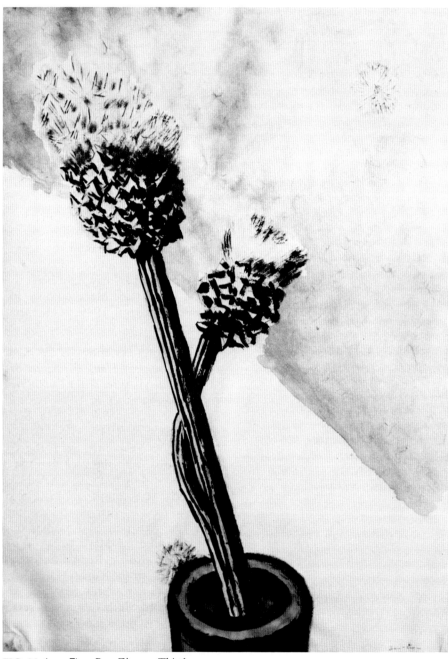

FIG. 11 (no. 7) Ben-Zion *Thistles*

Department's Art," *New York Journal-American,* November 19, 1946, and November 26, 1946. Reeves Lewenthal, chairman of the board of governors of Associated American Artists was reportedly approached to write the series for the *Journal-American,* but he expressed sympathy with the State Department paintings and the offer was withdrawn. See Letter, Heindel to Chairman Board of Governors of Associated American Artists, Inc. Reeves Lewenthal, December 20, 1946, DS 811.42700(A)12-2046, RG 59, NA.

25. "Exposing the Bunk of So-Called Modern Art," *New York Journal-American,* December 3, 1946.

26. Ben Shahn's *Hunger* and Kuniyoshi's *Circus Girl Resting* were two of the most widely reproduced images from the exhibition. The *Circus Girl,* for example, appeared in *Time, Newsweek, Washington Post,* and the *Republican News.* Both works were reproduced in the *Look* article.

27. "State Department Banned from Exhibiting Modern Art," *Washington Post,* May 6, 1947, 1.

28. "Collection of American Art Held Unfair to U.S. Women," *Washington Post,* February 13, 1947, sec. C, p. 7.

29. *Ibid.*

30. Transcripts, Fulton Lewis's Broadcasts, February 5 and 7, 1947, RG Benton, Art, Box 7, NA. Lewis's program, "Top of the News from Washington" was 15 minutes in length and broadcast over 130 MBC stations in the United States.

31. Letter, Mrs. John Duncan to Senator Kenneth McKellar, February 17, 1947, RG Benton, Art, Box 7, NA.

32. Letter, Henry Collidge Learned to Representative George Bates, February 10, 1947, RG Benton, Art, Box 7, NA.

33. Letter, President Harry S. Truman to Benton, April 2, 1947, RG PPF-

45F, Harry S. Truman Archives, Independence, Missouri. For Truman's further comments on modern art see ed. Robert S. Ferrell *Off the Record: The Private Papers of Harry S. Truman,* (New York: Harper and Row, 1980), 729, 299, 311, 336.

34. The *Republican News* layout is reproduced in "It's Striking, but is it Art or Extravagance?" *Newsweek,* August 25, 1947, 17.

35. An account of Benton's participation in the *Advancing American Art* project is contained in Sydney Hyman, *The Lives of William Benton* (Chicago: The University Press, 1969), 377-382. Official records demonstrate Benton had approved the concept of the exhibition but had not concerned himself with specifics. See Statement, *Advancing American Art,* February 20, 1947, RG Benton, Art, Box 7, NA; and Ninkovich, "The Currents of Cultural Diplomacy," 232.

36. The Republican National Committee in preparation for the 1948 elections had singled out Benton's information programs for attack. See Hyman, *Benton,* 375.

37. "Best in U.S. Art? They Find It Crazy," *New York Journal-American,* February 19, 1947.

38. See Memorandum, Oliver McKee to Benton, February 12, 1947, RG Benton, Art, Box 7, NA, for an assessment of political ramifications of the exhibition.

39. See Memorandum, The Art Program, February 10, 1947, RG Benton, Art, Box 7, NA. Regarding the requests received from embassies for exhibitions containing modern art, Representative Fred Busbey claimed their requests had been solicited by Davidson after the *Advancing American Art* collection was formed. Kent Hunter, "Says U.S. 'Faked' Demand for Art," *New York Journal-American,* May 14, 1947.

40. Gen. Marshall's statement to the House Appropriations Committee is quoted in Memorandum, Alice Curran to Benton, March 5, 1947, RG Benton, Art, Box 7, NA.

41. Benton had attempted on his own to "weed out" suspected Communist sympathizers. See Hyman, *Benton,* 375, 376. Ninkovich states that the holdovers from the "New Deal" in the State Department were suspect in Congress as fellow travelers. Ninkovich, *The Diplomacy of Ideas,* 122.

42. The House of Representatives' Committee on Un-American Activities records on twenty-four artists included in *Advancing American Art* are printed in U.S. Congress, *Congressional Record,* 80th Cong., 1st sess., May 13, 1947, vol. 93, pt. 4, pp. 5279-5282. They cite the politically liberal affiliations of artists such as Ben Shahn, Philip Evergood, and William Gropper, who were affiliated with organizations such as the Communist publication *New Masses* and the John Reed Club.

43. See Memorandum of Conversation, The Art Program, March 10, 1947, RG Benton, Art, Box 7, NA. On April 4, 1947, the Hearst press learned from an unidentified source in the "Budget Bureau" of a telegram from Secretary of State Marshall to the embassy in Prague ordering the works to be held there and not sent to further exhibition sites. In an article published that day, the press took credit for the termination of the collection's tour, stating, "Attention of the American public was first called by the *N.Y. Journal-American* and other Hearst newspapers last year to the weird State Department's collection of ineptitude and neuroticism which went by the name of modern American art." "Marshall Halts World Tour of Red-Linked Art," *New York Journal-American,* April 4, 1947. On April 6, they quote a further source at the State Department as indicating that the paint-

ings would be disposed of "at public auction." $49,000 Debunked 'American Art' on It's Way to Ashcan," *New York Journal-American,* April 6, 1947. In spite of this assertion, records of the art program (see records cited in footnote 39) show that no decision regarding what to do with the works after the tour was halted was made before June of 1947. Telegram, Marshall to American Embassy, Prague, June 11, 1947, DS 811. 42700(A)/6-1147, RG 59, NA ordered their return to the United States. It is reasonable to assume that these published allegations, however, had some influence on the final decision to actually sell the works.

44. Benton dictated a memorandum for his former secretary Alice Curran to "have the story straight for once." He indicates that not commenting on the photographs "may have been the wrong tactic." See Memorandum for the Files, January 5, 1949, RG Benton, Art, Box 7, NA.

45. Benton's testimony is recorded in *U.S. Congress, House Hearings Before the Subcommittee of the Committee on Appropriations on the Department of State Appropriation Bill for 1948,* 80th Cong., 1st sess., 1947, 412-419. The "documents" exhibited were the reproductions from the *Look* magazine article, according to Professor Richard McKeon who accompanied Benton to the hearings. Further attacks on the collection were delivered on the floor of the House on May 14, 1947 by Clarence I. Brown, Republican from Ohio, and John E. Rankin, Democrat from Mississippi. See the Congressional Record, 80th Cong., 1st sess., Vol. 93, pt.4, pp. 5286-7.

46. See "Artists Protest Halting Art Tour," *New York Times,* May 6, 1947, 24.

47. The State Department had an art advisory panel prior to 1938 but it was allowed to lapse during the War.

When art staff attempted to form another such group in 1947, they had problems getting the various clearances necessary. The reason given by Heindel for their difficulties was that "some very eminent names in the art world must have been listed in the House Committee [on Un-American Activities] in one connection or another." See Memorandum, Heindel to McKee, April 2, 1947, RG Benton, Art, Box 7, NA.

48. Memorandum, John Howe to Benton, June 9, 1947, RG Benton, Art, Box 7, NA.

49. Kenneth Holland of Benton's staff consulted informally with five prominent art experts to ascertain what reaction to the sale would prevail in the art community. They were Duncan Phillips, director of the Phillips Memorial Gallery; James Johnson Sweeney, former director of painting at the Museum of Modern Art; Daniel Rich, director of the Chicago Art Institute; Perry Rathbone, director of the City Museum of St. Louis; and Grace McCann Morley, director of the San Francisco Museum of Art. All felt that the State Department was wrong to abandon the exhibition but that sale of the paintings was the only alternative under the circumstances. See Memorandum, Assistant Director Office of Information, and Educational Exchange Kenneth Holland to G. Stewart Brown, October 29, 1947, RG Benton, Art, Box 7, NA. The dispute between the department and the War Assets Administration is recounted in an article by columnist Fred Othman, "Scrambled Egg Art Sale," *Washington News,* May 14, 1947.

50. State Department staff provided the War Assets Administration with suggestions for appraisers of modern art. They included Edith Halpert, Paul Rosenberg, Alan Grushin, and Antoninette Kraushaar, all commercial art dealers. It is not known who performed the actual appraisal. See Memorandum, Acting Chief Division of Libraries and Institutes Carl A. Sauer to Bruce McDaniel, October 12, 1947, RG Benton, Art, Box 7, NA.

51. Results of the sale were published by the American Federation of Arts as *Concerning WAA Sale No. WAX-5025* dated June 25, 1948. They were summarized by Carl Sauer in Interim Report on Sale of Paintings by War Assets Administration, July 2, 1948, RG Benton, Art, Box 7, NA.

52. See Memorandum for the Files, January 5, 1949, RG Benton, Art, Box 7, NA and Hyman, *Benton,* 382. Benton's career in government was not permanently affected by the "art scandal." After resigning from the State Department in 1947 he became the U.S. representative to UNESCO and, later, a senator from Connecticut.

53. Such attacks had a long history spanning the decades of the 1930s, 1940s and 1950s. See Mathews, "Art and Politics in Cold War America," previously cited for the developments that led to the full scale attacks of the 1950s during the "Red Scare." The ultimate irony of these claims was that Communist governments had no more approval for such art and artists than the conservatives in the United States.

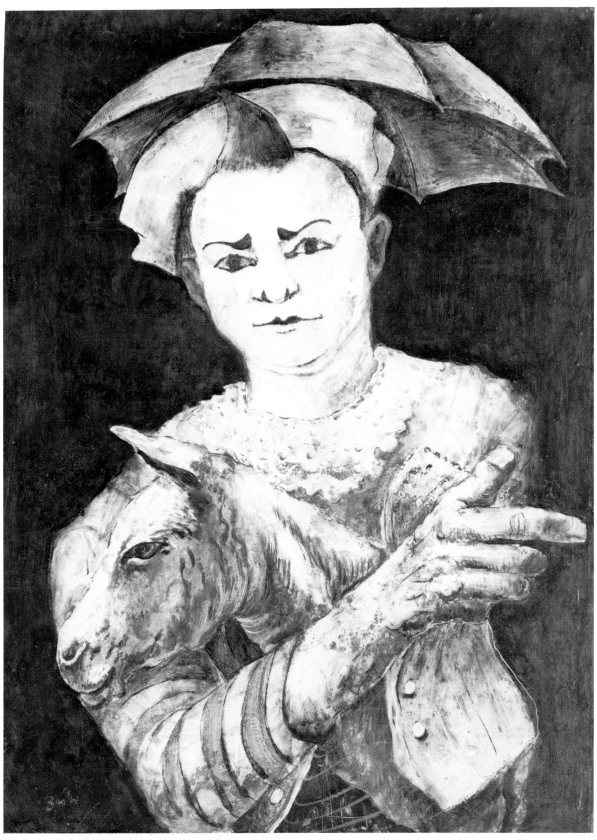

FIG. 12 (no. 73) Karl Zerbe *Clown and Ass*

34

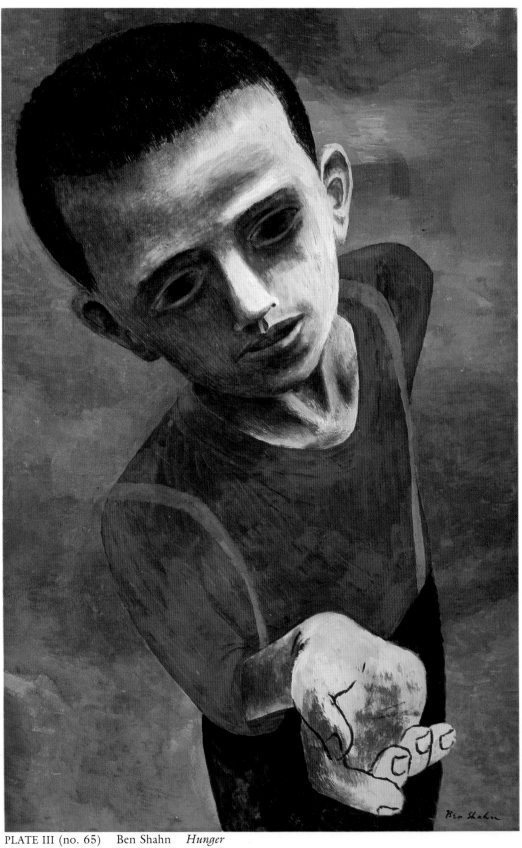

PLATE III (no. 65)　Ben Shahn　*Hunger*

by Virginia M. Mecklenburg

Advancing American Art

A Controversy of Style

The author is Associate Curator of 20th Century Painting and Sculpture at the National Museum of American Art.

When *Advancing American Art* premiered at the Metropolitan Museum in October 1946 prior to departing for Europe and South America, art critics hailed it as a cultural landmark.[1] Almost immediately, however, the Hearst press launched an all-out attack against the exhibition. Its *New York Journal-American* lambasted the paintings and illustrated one of them, Everett Spruce's *Turkey,* with a caption reading "Giving us the Bird;" the *Baltimore American* openly accused the State Department of promoting left-wing painters who were members of "Red Fascist" organizations. The conservative American Artists Professional League (AAPL) damned the show as a "one-sided" view of American art, and politicians fearful that a New Deal revival was at hand decried the expenditure of taxpayers' money.[2] Behind these reactions lurked unstated beliefs that American painting should reflect a positive view of American life, that American art touring Europe and Latin America under U.S. government auspices should be a de facto advertisement for free world values.[3]

Putting together an exhibition of advanced directions in American art was a complex and controversial proposition in the mid 1940s. With the intensity of U.S. involvement in European reconstruction, any federal venture into the international exhibitions arena was inevitably fraught with preconceptions. Compounding the challenge of presenting the most progressive trends in the art of the United States—in itself no simple task—was the conviction that art could help unify the fractured world. The Round Table on the Creative Arts, a blue ribbon committee of cultural leaders, for example, urged UNESCO to undertake arts programs because, they said, it was the

> humanists—the historians, the philosophers, the artists, the poets, the novelists, the dramatists—all those who fashion ideas, concepts and forms that give meaning to life and furnish the patterns of conduct . . . who really construct the world we live in, and it is they who, with sensitive awareness to human perplexity and aspiration and with the power of imaginative presentation, can speak effectively to a distracted world.[4]

Ostensibly, of course, *Advancing American Art* was the U.S. government's response to legitimate requests from European and Latin American nations to see modern American art. For State Department officials these inquiries provided the perfect opportunity to repudiate myths of American materialism and show, as Assistant Secretary of State William Benton said, that "the same country which produces brilliant scientists and engineers also produces creative artists."[5] With

a progressive exhibition they also could demonstrate that American artists numbered among the world's great humanists in fashioning the forms that give meaning to life.

Complicating the task of organizing an exhibition that would be modern and also a reflection of contemporary social and cultural attitudes was the fact that federal involvement in international exhibitions itself marked a new and still controversial concept. The State Department in the early forties had organized several small watercolor shows that traveled abroad, but they received little press coverage and went almost unnoticed in American political circles. This was probably just as well, since the notion of federal arts involvement had never received broad-based political support. Apart from individual commissions (memorials, monuments, and the embellishment of federal buildings), it was not until the Roosevelt administrations of the 1930s that the U.S. government inaugurated programs to support art and artists. The best known, of course, were the WPA's art, theater, music, and writers' projects. In addition, as offshoots of work relief efforts, the Civilian Conservation Corps, the Farm Security Administration, and other groups mandated through New Deal legislation provided funding to assist artists economically, and in the process to document the life of the American people. Despite their generally positive reception in artistic circles, these activities had aroused strong political controversy. Many of Roosevelt's opponents considered the WPA's cultural programs to be experiments in socialism as well as spawning grounds for social unrest. The repeated failure of attempts to establish a permanent department of fine arts within the executive branch during the thirties stemmed partially from political misgivings about the direction and validity of the WPA.[6]

The single New Deal arts program to escape bitter political confrontations was the Treasury Department's Section of Fine Arts, and its success was due largely to close control over style and subject matter in the art it commissioned.[7] Formed in the fall of 1934, this division selected artists through quasi-democratic competitions to paint recognizable events of local or historical interest on the walls of federal buildings, primarily small town post offices. Aware of the public nature of the sites and the tenuous acceptability of publicly funded art, the section's staff systematically encouraged artists to paint "American" myths and values and maintained rigorous standards for style and subject matter. Neither abstract compositional formats nor themes of social dilemma were acceptable. For example, when Bradley Walker Tomlin proposed to paint a mechanical abstraction for the Department of Labor, he was asked to redesign using a "realistic" format.[8] Similarly, Fletcher Martin's sketch for the Kellogg, Idaho, post office, which showed two miners carrying an injured companion on a stretcher, was rejected due to protests from local mining interests.[9]

Instead, Treasury Department officials sought optimistic scenes of contemporary American life or positive interpretations of local historical events.[10] As long as mural designs showed constructive social or economic enterprise they passed the stiff review board. Consequently, although Marion Gilmore took considerable license with town geography in her Corning, Iowa, post office mural, the scene of warm human companionship depicted in her *Band Concert* perfectly accorded with local perceptions of town life. In a glowing letter of thanks to section officials, a Corning citizen wrote that the town was delighted with the mural because it "so truthfully" depicted the town's "happy, community way of life."[11] Given contemporary attitudes, this mural program, and

the thematic and stylistic censorship it exercised, was probably the only politically viable mechanism of federal art support. Its subtle, but pervasive propagandistic program overrode an otherwise strong antipathy to governmental involvement in art.

Shortly after U.S. entrance into World War II, the WPA and Treasury programs ended. Yet several war-related agencies continued to employ artists in small numbers precisely because paintings could so directly and succinctly communicate national messages. Only a week after the attack on Pearl Harbor, the Office of Emergency Management held an open competition calling for art works depicting defense activities. From some twenty-five hundred paintings submitted, over one hundred were purchased for reproduction on posters. The War Production Board, the U.S. Army and Navy, the Treasury Department's war bonds division, and several civilian defense organizations all followed suit.[12] Throughout the war years the American public was flooded with mass-produced images urging national unity and support of the defense effort. Thus, apart from the laissez-faire WPA, federal patronage prior to *Advancing American Art,* and particularly during the war years, was firmly associated with the communication of public values.

Art's propagandistic potential was widely exploited during the late thirties and early forties in corporate spheres as well. In 1938 the Dole Pineapple Company commissioned a group of artists, including Georgia O'Keeffe, Isamu Noguchi, Yasuo Kuniyoshi, and others "to create pictorial links between pineapple juice and tropical romance."[13] Although not the first, Dole's commissions were probably the most publicized instances in which "fine artists" were selected instead of commercial artists or illustrators. Recognizing the financial boon corporate commissions offered, artists nonetheless confronted the dilemma of main-

taining their aesthetic integrity without abrogating their responsibility to convey a corporate message.

The Dole commissions were fairly successful in this respect; however, the approach taken by the Upjohn Company of Kalamazoo, Michigan, underscored the potential pitfalls of mixing art and commerce. Upjohn purchased a number of existing paintings for a poster series and ad campaign called "Your Doctor Speaks." The paintings were reproduced with captions supplied by the company, and the resultant images were used in magazine layouts and as wall decorations for doctors' offices. A poster made from a Bernard Karfiol canvas of a seated figure bore the inscription "And they thought she'd always be paralyzed." Similarly, Fletcher Martin's portrait of a (presumably) pallid woman was published with the query "Anemia?"[14] In both instances the aesthetic qualities of the art became ancillary to a medical lesson.

Despite the heavy-handed labeling of the Upjohn posters and the undeniable advertising component that the Dole commissions entailed, by the early forties industry had emerged as an important source of patronage. Even though mundane messages were appended, corporate advertising made fine art reproductions accessible to millions of Americans.[15] Furthermore, the growing number of companies that had begun serious art collections (IBM, Encyclopaedia Britannica, Container Corporation of America, Standard Oil of New Jersey, Pepsi-Cola) ameliorated the negative connotations often associated with industry's patronage of art.[16]

On several occasions during the war, American business and government had joined artistic forces. Abbott Laboratories of Chicago commissioned paintings that were shown as part of a war bonds fund-raising program, and other firms helped in similar ways. Although these corporate ventures did not relate

directly to the State Department's exhibition program, they provided models and helped cement convictions that art could effectively communicate a predetermined set of values. Thus, when the State Department was approached by the *Société des Amis d'Art* in Cairo shortly after the end of the war for an exhibition of nineteenth and twentieth century American painting, it seemed logical to turn to industry for assist-

FIG. 13 (no. 8) Louis Bouché *Gallery K*

ance. The resulting show, *Sixty Americans Since 1800,* provided the only real conceptual prototype for *Advancing American Art*. Drawn from the collection of International Business Machines, the exhibition surveyed two hundred years of American art in relatively chauvinistic terms. Featuring paintings by such incontrovertible American masters as Thomas Cole, Asher B. Durand, and Samuel F. B. Morse, in addition to more recently recognized talents such as George Luks,

38

PLATE IV (no. 42) Edward Hopper *House, Provincetown*, 1930

PLATE V (no. 53) John Marin *Seascape*, 1940

Edward Hopper, and Grant Wood, the exhibition premiered in Cairo, then joined paintings from other corporate collections and toured Europe as *American Industry Sponsors Art.*[17] Traveling under State Department auspices, these exhibitions beautifully illustrated the cultural commitment of "materialistic" American corporations and demonstrated the breadth and quality of American art. Egyptian and European

FIG. 14 (no. 51) Jack Levine *Horse,* 1946

responses to the show were favorable, and the historical focus prompted the U.S. press to congratulate both government and industry for an exemplary presentation of American values abroad. Although not initially intended as a propaganda tool, *Sixty Americans* nevertheless was perceived as an important element in an American post-war public relations campaign.

In organizing *Advancing American Art,* J. LeRoy Davidson was acutely aware that the show would be seen as a statement of contemporary American

values. Throughout his exhibition—in the artists chosen as well as those omitted and in the selection of specific works from the variety of available possibilities—there runs a conceptual image of the United States as a nation of humanistic, unprejudiced, and strongly individual people. But Davidson's appreciation of U.S. civilization at the war's end and the values he hoped to convey in the exhibition diverged dramatically from those of the show's detractors.

To understand fully the controversy that led to closing *Advancing American Art,* it is necessary to examine the then current preconceptions about American art and how Davidson's selections diverged from or coincided with these expectations. It is not enough to ascribe the difficulties merely to antagonism against the Social Realism of a Ben Shahn or an O. Louis Guglielmi painting, or to suggest that conservative taste simply could not accept the abstract art that Davidson included, although both were part of the problem. Individual canvases as well as stylistic genres evoked intellectual associations that were as important in the minds of the show's detractors as the visual images themselves.

By the mid forties, American painting presented an immensely diverse array of styles, each of which was loosely associated with a social or philosophical attitude. Regionalism and American Scene painting, which often idealized American rural life, continued to capture the hearts of the public well into the forties. Academic figure and landscape painting, with their concomitant suggestion of a mature national aesthetic development, flooded the contemporary shows at the Corcoran, Carnegie, and Pennsylvania Academy, as well as the National Academy of Design in New York. As in the previous decade, the leftist orientation of Social Realism still sparked controversy, and across the country, through magazine articles as well as exhibitions, the odd

fantasies of Surrealist painting simultaneously repelled and fascinated the American people. The more difficult idioms of abstraction and Expressionism, arguably the most experimental work then being done, were inextricably linked in the public consciousness with the European avant-garde.

From these stylistic possibilities, Davidson constructed an exhibition weighted heavily towards abstraction and Expressionism, and all but devoid of Regionalist and American Scene paintings. Figurative works by progressive artists balanced the show, and the inclusion of painters working far from New York (Everett Spruce in Texas, Georgia O'Keeffe in New Mexico) suggested the geographical breadth of American creativity.

A quick survey of the exhibition indicates that aesthetically, at least, Davidson was on fairly firm ground. A number of the artists, including Jack Levine and Robert Motherwell, were still fairly young, but the show also featured, as Alfred Frankfurter remarked in the *Art News* issue devoted to *Advancing American Art,* a number of America's contemporary "old masters."[18] John Marin, Georgia O'Keeffe, Marsden Hartley, and Arthur Dove, all of whom had been members of the avant-garde circle around Alfred Stieglitz during the 1910s, were highlights of the exhibition. The same was true of Max Weber, Walt Kuhn, and Gifford Beal, although Kuhn and Beal had consistently retained more traditional styles, and Weber had long since given up the Fauve and Cubist inclinations that had characterized his most progressive phase. To an artistically seasoned eye, *Advancing American Art*'s catalogue read like a compendium of prize winners in the nation's largest salon shows, and in many instances paralleled recent corporate and museum purchases. Over half the painters in the State Department show, for example, were also included in the Britannica and IBM collections.

Why, then, did *Advancing American Art* arouse such vociferous hostility? What prompted the charges of communist influence?

In emphasizing abstraction and Expressionism, styles that were intellectually and stylistically associated with European prototypes, Davidson tacitly rejected a nativist philosophical slant that would probably have ensured his project's success. In fact, the charge most frequently leveled at the show—that *Advancing American Art* failed to embody American democratic values—related in part to the dearth of American Scene imagery. For over a century popular ideas about art had been shaped by the belief that art served as "anthropological" evidence of a nation's philosophical and intellectual condition. In the mid eighteen hundreds Herbert Spencer in England and Hippolyte Taine in France both systematically discussed art as cultural artifact, and the roots of their philosophies reached as far back as Greek thought. Apart from their influence in Europe, Spencer and Taine had a tremendous impact on nineteenth century American attitudes as well. From the decision to use corncob and tobacco leaf motifs instead of acanthus foliage on Corinthian columns in the U.S. Capitol to the populist sympathies conveyed by Robert Henri and John Sloan, the idea that art mirrored atavistic and cultural attributes had historically played an important role in American art and theory.[19] As apparent from the immense popularity of John Dewey's writings and of Regionalist paintings during the thirties and the relative public and political success of the Treasury Department's post office murals, the idea that American art could accurately capture American values had reached new heights.

Yet even the artistically well-informed disagreed about what "national characteristics" actually were and how they could be conveyed in contemporary paintings. Many, notably the Regionalists, believed that national art meant native scenery, an assumption held by many of *Advancing American Art*'s detractors. Others, including *Chicago Daily News* critic C. J. Bulliett, stressed that native schools embodied a generic spirit of "time and place that gave [them] birth," rather than any sort of native imagery.[20] Art historian Robert Goldwater invoked Robert Henri's words and insisted that national values were embedded in an artist's psychological makeup; simply by following the dictates of his conscience, a painter inevitably reflected native values.[21] When Goldwater further suggested that internationalism was replacing more distinctly local concerns in the minds of contemporary artists, he hinted at one of the basic problems with the State Department show. In the catalogue for *Advancing American Art* produced by the U.S. Information Agency in Prague, author Hugo Weisgall firmly identified the American spirit as an impulse toward internationalism. Linking art with social growth, he characterized American painting as a slow, but inexorable, movement toward the idea of "one-world" rather than one nation: "As the idea of America has subordinated the concept of racial origins, so the growing international fabric of culture has subordinated nationality in the arts to the individual."[22] In his terms, individualism was synonymous with internationalism.

What Weisgall and Goldwater identified as an American spirit was actually the adoption of a cosmopolitanism prevalent in Europe since the turn of the century. Proposing that an artist's individual expression was more important than identification with a specific national tradition, this notion of internationalism had just begun to gain popular acceptance in the United States when the Depression shifted the nation's consciousness toward local and regional concerns. Although artists continued to work in distinctly international veins, the public seemed to

prefer scenes evocative of pioneer values, personal fortitude, and independent spirit—usable elements from the American past—that were typical of Regionalist painting. Davidson, however, was charged with presenting "progressive" American art, a niche with no room for nostalgic scenes of American life, and he specifically bypassed Regionalists Thomas Hart Benton, Grant Wood, and John Steuart Curry.

Essentially a conservative approach, by the early forties Regionalism had come under severe critical attack in artistic circles as stylistically retardataire and thematically insular. Art historian and then critic H. W. Janson called the movement "dangerous" because it attempted to substitute some sort of ill-defined Americanism for real aesthetic values. In rejecting urban life in favor of a return to the land, he wrote, Regionalism nourished isolationist values that were antithetical to the democratic principles its followers professed.[23] James Thrall Soby of the Museum of Modern Art criticized Regionalism on similar grounds. The artists, he said, adopted a "bully-boy xenophobia and almost secessionist temper" that resulted in "perverse and inflated" propaganda.[24]

If the omission of American Scene painting suggested to critics that Davidson was ignoring traditional values, the inclusion of several Social Realist paintings gave rise to serious charges of "communist" support. Jane Mathews, who has studied the artistic climate during the McCarthy era, suggests that redbaiting enthusiasts from these years viewed all statements critical of American society, whether overt or embedded in literary or artistic iconography, as evidence of undemocratic attitudes. They also questioned the patriotism of artists belonging to leftist organizations and considered them unreliable spokesmen for democratic values. Thirdly, Mathews says, art with distorted or abstract imagery denied traditional beauty and consequently was considered anti-American.[25]

Viewed in these terms, Davidson's exhibition was guilty on all counts. Shaped partially by exigencies of price and availability, his selections nevertheless consciously flew in the face of conservative expectations. Ben Shahn's *Hunger* and *The Clinic* (Fig. 15) pulled no punches in pointing out serious deficiencies within American society. *The Clinic,* especially, raised the politically charged issue of public health programs for the needy and was consequently read as both critical of American society and supportive of socialist welfare schemes. Along similar lines, in *Tenements,* O. Louis Guglielmi drew an implicit connection between poor housing conditions and death. It was no accident that he crowned the tenement building with a funereal wreath and painted the coffins in the colors and textures of the building's materials. Davidson must have realized the furor the Shahn and Guglielmi canvases would cause and included them for other reasons than their social comment. Apart from these works, none of Davidson's selections challenged the American social or economic establishment. Instead they reflected a deep-seated concern for mankind and a severing of chauvinistic national boundaries that seems uniquely appropriate to the timing of the exhibition. Had the rest of the show been acceptable, it might have been possible to assuage opponents merely by removing the offending images. Yet this possibility seems not to have been raised. Obviously, the objections went deeper.

Apart from Shahn's and Guglielmi's "undemocratic" imagery, charges that the State Department was actively supporting members of communist organizations stemmed primarily from Davidson's inclusion of works by William Gropper, Stuart Davis, and Philip Evergood, as well as Shahn. All had been involved in the American Artists' Congress from its inception in 1936 and active in other radical groups as well. Although several were avowed Marxists, most of the artistic associations they belonged to were anti-fascist, established not as communist plots against democracy but as idealistic attempts to ensure that democratic principles were applied equally to all.[26] Furthermore, Davidson selected paintings by these militants that reflected universal concerns about humanity rather than doctrinaire political views. For example, rather than themes of social unrest, Davidson chose anti-war images by William Gropper and Philip Evergood. It is ironic, given the universality of their paintings, that Gropper's and Evergood's political inclinations, rather than their messages, sparked such controversy.

In some respects both artists exemplified the worst fears voiced by *Advancing American Art*'s detractors. A well-known Social Realist painter, Evergood actively supported liberal and radical causes during the 1930s. An early member of the Artists Committee of Action and president in 1937 of the Artists Union, he also signed the call for the American Artists' Congress and worked on behalf of civil rights, the loyalist cause in the Spanish civil war, and the Finnish war relief program. While managing supervisor of the easel division of the New York City Federal Art Project, he fought aggressively to keep good artists on the relief rolls and was arrested for participating in a strike protesting layoffs.

Many of Evergood's paintings from the thirties and forties centered on themes related to his socially motivated political affiliations. Layoffs were depicted in *The Letter* (1937), industrial safety in *Mine Disaster* (1933-1936), and the contrast of wealth and poverty, white and black, in *Fat of the Land* (1941). Others punctuated social commentary with vignettes of human feeling. A 1937 canvas entitled *An American Tragedy* showed a clash between strikers and policemen brandish-

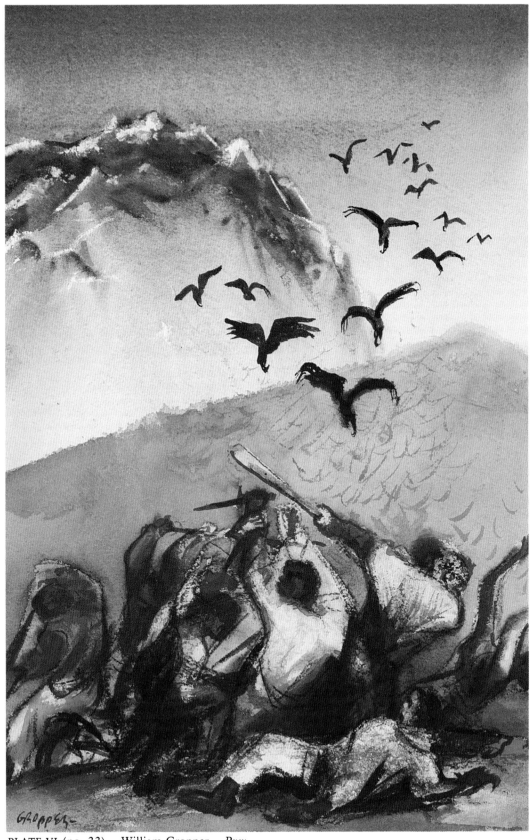

PLATE VI (no. 33) William Gropper *Prey*

ing clubs during a rally at the Republican Steel Corporation on Memorial Day, 1937. Mollifying its reference to a specific event, however, the painting makes a larger statement about human affection. As John Baur points out, the painting's central figures are a demonstrating worker protecting his pregnant wife from the dense pack of struggling forms.[27]

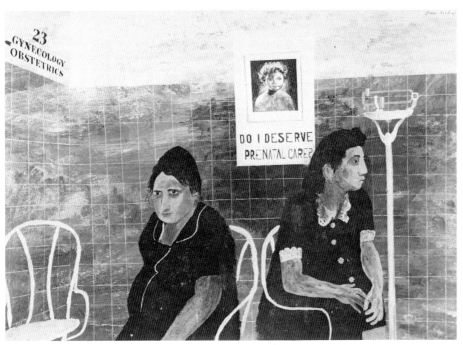

FIG. 15 (no. 64) Ben Shahn *The Clinic,* 1944-45

In the Prague catalogue for *Advancing American Art,* Hugo Weisgall admitted Evergood's ability to penetrate "the dark shadows of contemporary life," but he emphasized the "ingenuous charm" of the artist's paint handling and "engaging sense of humor."[28] True for many of Evergood's paintings, these latter qualities obscure the potency possible in his strongest work. In *Fascist Leader,* (Fig. 16), the painting Davidson chose for the exhibition, chained prisoners trudge across a desolate townscape, under the directing arms of a Napoleonic skeleton, while a "guardian angel" skeleton hovers above. Here Evergood couched moral outrage at the war in the stylistic lan-

guage typical of his social protest paintings, but his anti-fascist statement could not have been more clear.

Although less directly referential, the paintings by William Gropper that Davidson selected also despaired the devastation wrought by recent events. Gropper, too, was a political leftist and had been singled out by the *Baltimore American* as one of the "members of Red Fascist organizations" that the State Department was ostensibly supporting. Yet his paintings in *Advancing American Art* contained neither the cynicism nor the satirical barbs typical of Gropper's socially charged paintings and prints. Instead of politicians ranting or judges asleep at the bench, the works Davidson sought were ones indicative of Gropper's deep-seated hatred of war and his far-reaching familiarity with art history. In *They Fought to the Last Man,* (Fig. 17), for example, a rocky hill is strewn with faceless, anonymous, white-shirted bodies and two struggling figures capping a pyramid of death. Absent is the glory of battle; the forces that prompted this destruction of human life also remain unstated. Here and in *Prey,* (Pl. 6), a watercolor of vaguely similar landscape and theme, Gropper painted the brutality and senselessness of war. That his message transcended the time and place of recent events is suggested by the marked similarities between Gropper's oil and Francisco Goya's *Third of May, 1808,* as well as *Prey's* resemblance to the Spaniard's *The Sleep of Reason Produces Monsters.*

In these paintings, as in Anton Refregier's *End of the Conference* (Fig. 18) and Julio de Diego's *Stiff Rearguard Action,* (Fig. 21), both of which Davidson included in his exhibition, social comment is subsumed within disillusionment over the collapse of human moral and ethical values. Statements of sympathy rather than criticism, they offer a dramatically different understanding of mankind than did paintings of the American scene.

FIG. 16 (no. 28) Philip Evergood *Fascist Leader*, 1946

PLATE VII (no. 19) Stuart Davis *Trees and El*, 1931

More fundamental than the question of social comment, however, were the philosophical implications raised by Davidson's emphasis on Expressionist and abstract paintings. Distinctly international in inspiration, these two styles represented the antithesis of Regionalist values and aroused considerable skepticism. Although engaging in a non sequitur, uninformed observers assumed that by rejecting traditional forms and familiar subjects abstract and Expressionist artists also renounced traditional democratic world views.

As defined in the forties, Expressionism served as a catch all phrase for paintings that conveyed a deeply personal vision. Generally tied to natural appearances, expressionist art distorted observed reality for heightened emotional effect. At times lyrical and beautiful, expressionist paintings could also be harshly confrontational, emotionally disturbing, and enigmatically symbolic. Rooted in German avant-garde painting from the turn of the century, Expressionist painting in the United States represented a distinctly international viewpoint and raised the problematic issue of American artistic maturity versus European derivation. The strongly individualistic bent and stylistic devices typical of the German Expressionists (dissonant color and brutal, slashing brush strokes), provided important intellectual and emotional sources, if not always direct visual prototypes, for American painters of the thirties and forties. The strength of their appeal for Americans prompted Robert Coates of *The New Yorker* to remark in 1943 that, next to Cézanne and Picasso, Chaim Soutine and Oskar Kokoschka had "a stronger and more direct influence on the younger generation than any other artists."[29]

In recent years the importance of American figurative Expressionism has been largely overshadowed by the attention accorded Abstract Expressionism. But, as Piri Halasz indicates, the former type of Expressionism was a force to be reckoned with. During the 1940s, she reports, the fourteen leaders in the style had seventy-five one-man shows in New York alone.[30] By the middle of the decade positive critical reception had become the rule rather than the exception.

In a 1943 survey of progressive American painting Samuel Kootz distinguished the style's unique possibilities:

Whereas the Abstractionists seek definite statements, bold flat color and crisp forms, the Expressionists attempt a more obscure approach to their objectives. They use the psychology of color (grays and blacks and solemn blues and reds) to express a moody, mystic *weltschmerz*. Their statements are primarily emotional rather than intellectual. Their craftsmanship is loose, almost archaic in the use of fuzzy lines and insecure contours to create a somber aura for their passionate forms. . . .[31]

Kootz, a businessman turned gallery owner, viewed Expressionism in psychological terms, although neither he nor others directly linked the style with the Freudian and Jungian concepts pertinent to the Surrealist manifestoes. Yet in exploring human feeling, itself not a fully conscious phenomenon, this generally idiosyncratic and emotionally charged idiom probed similar depths and in some cases resulted in formal devices as iconographically complex as those of Salvador Dali or Yves Tanguy.

Although achieving prominence in the forties, Expressionism's basic philosophy had characterized the work of several early modernists in New York. John Marin and Marsden Hartley had explored private feelings in their canvases of the 1910s, although by the 1940s both had long since given up the quasi-Cubist forms typical of their early avant-garde paintings. The intense, deeply personal responses to nature apparent in the Marin seascapes and Hartley still life and landscape compositions included in *Advancing American Art* were psychologically consistent with paintings each had shown at Stieglitz's galleries. Their continued search for the mystical (and the ever-present difficulty of categorizing artists according to predetermined labels) led James Thrall Soby to include both Marin and Hartley in the Museum of Modern Art's 1943 exhibition, *Romantic Painting in America,* under the guise of "Romantic Expressionism."

Other artists in *Advancing American Art,* notably Everett Spruce, Charles Burchfield, and Joseph de Martini, fit equally well into this slightly cumbersome "Romantic Expressionist" category. All were painters of mood, their canvases private interpretations of nature's forces or of the metaphysical implications of the world in microcosm. Whether exploring landscape motifs, as de Martini's *The Ravine* (Fig. 19) and Hartley's *Whale's Jaw, Dogtown,* (Fig. 20), or focusing on a single aspect of natural existence, as Spruce's *Owl on Rocks,* (Fig. 23), each probed beyond the physical realities that their subjects superficially implied. The close-up view of a Spruce owl, for example, and the closely related handling and tonalities of bird and background, suggested primordial relationships between living form and landscape that underlie spiritual and metaphysical existence.

That Marin and Hartley as well as Spruce, de Martini, and other lyrical painters took a relatively free approach to form, coupled with the very personal nature of their vision, aligned them in the minds of contemporary critics with other Expressionists. Yet their paintings were more easily understood. In its harsher manifestations Expressionism technically and thematically assaulted the viewer. George Grosz and Paul Burlin adopted the Expressionist idiom to communicate social statements—horror of war and disillusionment with a world society that permitted the large-scale destruction of

human life. In contrast with the Social Realists, they relied on heavy, agitated paint surfaces, as well as imagery, to create a psychological mood and to probe for emotional truth beneath superficial appearances. Others, including Karl Zerbe, developed complex symbolic imagery that appealed to head as well as heart. All depended on European precedents to provide stylistic construct.

FIG. 17 (no. 34) William Gropper *They Fought to the Last Man*

George Grosz, whose *Street Fight* was selected for the State Department exhibition, had come to New York from his native Germany during the summer of 1932 to teach a course at the Art Students League, and the following January he moved with his wife and family to the United States. From early on a social leftist, Grosz joined the German Dada movement because the program drawn up by Richard Huelsenbeck and Raoul Hausman called for an "international revolutionary union of all creative and intellectual men and women on the basis of radical communism."[32] Angry at an immoral society and profoundly disturbed by his

experiences in the German army during World War I, Grosz embraced Dada and, in 1918, joined the German communist party. He soon became well known for political cartoons that reflected his bitter disillusionment, yet his acerbic tone was rooted in a profound idealism that ultimately linked him conceptually with Gropper and Evergood. In a statement that could well have applied to a number of American artists of the thirties, Count Harry Kessler wrote of Grosz in 1922:

> The devotion of his art exclusively to depiction of the repulsiveness of bourgeois philistinism is, so to speak, merely the counterpart of some sort of secret idea of beauty that he conceals as though it were a badge of shame. In his drawings he harasses with fanatical hatred the antithesis of his ideal, which he protects from public gaze like something sacred. His whole art is a campaign of extermination against what is irreconcilable with his secret "lady love". Instead of singing her praises like a troubadour, he does battle against her opponents with unsparing fury like a dedicated knight. . . .[33]

After several bouts with German authorities over the messages of his political prints, Grosz found that New York provided a welcome change. The satirical tone of his works softened, and initially, at least, his paintings took on an uncharacteristic serenity. When requested to do cartoons for *Americana* magazine that would "scratch their eyes out," Grosz responded that "something of that spirit had died."[34] Nevertheless, as accounts of Nazi atrocities spread, Grosz began painting nightmarish visions of the emotional turmoil and psychological devastation of war. His surfaces took on complicated, swirling motions and impassioned rhythmic tempos that, with wracking intensity, recreated the turbulent upheaval of conflict. In *The Pit* of 1946, Grosz depicted a burning city in the

hot colors of a fiery hell. Violent death, prostitution, and fire join monster figures in a scene of chaotic power and compositional brilliance. The power of Grosz's paintings during the war years owed as much to their technical qualities as to their imagery. Although the *Street Fight* that Davidson chose for *Advancing American Art* has not been located, it is likely that it, too, possessed the emotional impact typical of Grosz's explicit battle scenes.

In purchasing *Street Fight* and Paul Burlin's *News from Home,* (Fig. 22), as well as the Gropper and Evergood paintings, Davidson dealt openly with the emotional traumas of war. That Americans, too, had suffered greatly during the previous years is apparent in Burlin's interpretation of inner conflict. The impact of *News from Home* is conveyed through form and handling rather than through image alone. The jagged shapes of dagger and teeth, the dissonance of spatial relationship, and the abrupt juxtaposition of threatening elements with dancing forms create disturbing disjunctions within the painting itself and also between visual meaning and title. Although not a symbolic work in the traditional sense, Burlin here used powerful formal characteristics—brush stroke; tactile, agitated surface; and misshapen form— as metaphorical elements so that his work affects mind as well as emotions.

Burlin's restless search for the reality behind appearances had also led him to create images of duality, inner contradiction, and fiercely contorted forms. An exhibitor at the Armory Show, he had explored the emotional possibilities of distorted form and color early in his career. In Paris from 1921 until 1932, Burlin experimented with the flatness and color organization of Matisse and the Fauves and with Cubist spatial formats, but his paintings retained overtones of feeling that belied his formalist excursions. After a stint as a Social Realist on his return to the United States, Burlin by the early for-

FIG. 18 (no. 62) Anton Refregier *End of the Conference,* 1945

FIG. 19 (no. 22) Joseph De Martini *The Ravine*

FIG. 20 (no. 40) Marsden Hartley *Whale's Jaw Dogtown*, 1934

FIG. 21 (no. 20) Julio De Deigo *Stiff Rearguard Action*, 1942

ties also rejected "false social responsibility that had little to do with paintings" and returned to a quasi-Cubist idiom with harsh, painterly surfaces.[35] Using Picasso's barbaric paintings of women from the 1930s as inspiration, Burlin attempted to charge his work with "conceptual voltage."[36] In a number of paintings, including his 1943 *Fallen Angel,* Burlin alluded with sardonic cynicism to human frailty, embedding his statement within a clearly symbolic vocabulary.

The American public had encountered obscure symbolism in the various Surrealist exhibitions that toured the country during the 1930s and 1940s and had alternately scoffed and adored the odd compositions they saw.[37] When wedded to expressionistic paint handling, however, symbolic compositions lost the "guessing game" quality they often took on in paintings by Dali and assumed disturbing, sometimes menacing demeanors.

Like Grosz, who was ten years his senior, Karl Zerbe had established a reputation as a promising young painter in Germany before immigrating in 1935 to the United States. Initially an Expressionist, by the late twenties Zerbe had adopted a dry, descriptive style akin to that of *Neue Sachlichkeit* (New Objectivity), a German movement of the twenties that countered Expressionist emotionalism with coolly detached, precise observation. By the time he arrived in Boston, where he settled, Zerbe had again realigned himself stylistically, this time synthesizing the objectivism of *Neue Sachlichkeit* with the Expressionist's powerful brushwork to arrive at a highly individualized and symbolic idiom. Attempting to free objects of their familiar connotations, he constructed contexts in which they became enigmatic emblems. Through distortions of scale and juxtapositions of unrelated images, Zerbe produced compositions that were profoundly disturbing in their refusal to permit specific interpretation.

In many of Zerbe's paintings, including the *Clown and Ass* (Fig. 12) in *Advancing American Art,* clowns, acrobats, and actors—figures of dual identity—symbolized moral dialectics. Through them the artist investigated oppositions within the human psyche—folly and wisdom, gaiety and melancholy, pretense and truth—while avoiding melodramatic or overly obvious allusions. Often employing a tripartite compositional arrangement, he paid homage to his German Expressionist friend Max Beckmann, whose metaphor-laden triptychs had a powerful impact on Zerbe's own work.

Although Zerbe's paintings are not widely known today, during the late thirties he had a formative influence on the development of a "school" of Expressionism in Boston. On his arrival he taught for two years at the Fine Arts Guild in Cambridge, and in 1937 he was asked to succeed the late Alexandre Iacovleff as head of the department of painting at the Boston Museum School. A technical maestro, Zerbe also served as an inspirational mentor to his students Jack Levine and Hyman Bloom.

In academic as well as progressive circles, Expressionism had begun to catch on by 1945, the year the Pennsylvania Academy of the Fine Arts' Temple Gold Medal was awarded to Abraham Rattner's *Kiosk.* Rattner saw the award as a breakthrough for Expressionism, indicating that at last opportunities were opening up for the "underdogs" in art.[38]

Like Zerbe, Rattner employed a symbolic, metaphorical vocabulary, often concealing moral statements behind religious facades. He, too, explored dualities using clowns as indicators, although Rattner's symbols were often more clearly readable than were Zerbe's. For Rattner also the expressive power of color and brushwork were as crucial in conveying psychological meaning as the symbols he employed. About a work entitled *Spontaneous Demonstration,* he

wrote that "it's representative of destruction, violent, but not unpleasant. Colors play on the imagination, like notes and tones in music. Realism can't do that."[39]

Like the work of his fellow Expressionists, Rattner's art had germinated abroad. He traveled to France on a fellowship in 1920 and remained in Europe until hostilities forced his departure in the fall of 1939. On his return to New York, Rattner skyrocketed to attention. Julien Levy, the dealer, featured his paintings on several occasions, and in 1942 Rattner joined Paul Rosenberg's gallery. By that winter his work had been included and generally well received in major salon exhibitions, and articles featuring his paintings had appeared in *Esquire, Newsweek,* and *Vogue* magazines, as well as in *The New Yorker* and a host of newspapers.

The paintings that Davidson selected for *Advancing American Art, Yellow Table* and *Bird Bath,* (Fig. 25), suggest sides of Rattner's work different from his symbolically oriented compositions and also indicated his technical virtuosity. *Bird Bath,* a lyrical interpretation in watercolor of flurrying wings and splashing water, suggested the importance within his approach of obedience to the possibilities inherent in medium. But Expressionism had a structural side as well, and Rattner's *Yellow Table,* like Max Weber's *Two Vases,* (Fig. 24), reiterated with brushy freedom the importance of form within the Expressionist idiom.

In selecting Expressionist paintings for *Advancing American Art,* Davidson not only provided a showcase for this newly recognized style, but thoroughly explored the breadth of possibilities it entailed, mixing works by younger painters with those by artists of well-established reputations. He balanced the metaphysical side of Hartley, Marin, de Martini, and Spruce against the traumatic emotionalism of Burlin and

Grosz, while works by Weber and Rattner indicated the more formal or structural possibilities. By including recently arrived German artists and by emphasizing paintings in which the adaptation of European stylistic precedents was paramount, Davidson presented a viewpoint that underscored a new internationalism in American art. Yet, with their generally unpretty surfaces, formal distortion, difficult symbolism, and thematic grappling with moral contradictions and the horror of war, the Expressionist paintings in the show collided with public expectations about art and beauty. Even the thematically neutral canvases of Marin and Hartley, lacking the crisp directness of a Winslow Homer coastal scene or the familiar softness of a George Inness twilight, invited introspection rather than recognition. Very simply, the Expressionist paintings were difficult for the uninitiated and unsuspecting eye.

If Expressionism was a diverse and difficult idiom during the early forties, the multiple varieties of abstraction should have been more familiar territory. In New York the Museum of Modern Art and the Guggenheim regularly featured nonobjective painting, and A. E. Gallatin's impressive collection was on view at New York University.[40] A number of commercial galleries featured avant-garde art, and by the early forties many of Europe's leading abstractionists had fled to the United States.[41] In 1942 art critic Rosamund Frost even argued that abstract principles had so thoroughly transformed the appearance of American life that architectural forms imitated the geometry of Dutch and Russian art, while contemporary magazine layout borrowed wholesale the techniques of Cubist collage. Given the wealth of opportunities to see abstract art in New York, Frost should have been on target in concluding that "even the most unrelenting conservative need not be alarmed about something he has lived alongside for forty-two years."[42]

Yet this prevalence of abstraction in the forties represented a resurgence rather than a continued tradition. Lloyd Goodrich observed in the catalogue for the Whitney Museum's 1946 show, *Pioneers of Modern Art in America* that many of the early moderns had reverted to figuration shortly after World War I, and that the twenties had actually marked a retreat from abstraction in the United States. Although by 1946 he considered nonobjective painting to be one of the "dominant tendencies" in American art, Goodrich also wondered if it were not somehow a war-related phenomenon: "Abstraction may serve as an escape from troubling realities into a world of aesthetic order where the artist is in full control, just as surrealism is an escape into the world of private fantasy."[43]

Fundamentally, however, Goodrich and most other knowledgeable observers of the time recognized that abstraction was an international language without reference to time or place. Given the generally international focus of *Advancing American Art,* it is no surprise that abstract or semi-abstract paintings made up a large and important segment of the show.

As with the Expressionists, abstract painters could not be described in neat, cohesive categories, and Davidson's selections represented their tremendous diversity. From the lyrical, nature-based paintings of Milton Avery and George Constant to the geometrically oriented works of Byron Browne, Ralston Crawford, and George L. K. Morris and the biomorphic allusions of William Baziotes and Charles Howard, Davidson attempted to present an in-depth cross section of the various aesthetic thrusts of abstract art in America.

On close examination, however, it becomes apparent that Davidson offered a lopsided view. He overwhelmingly stressed paintings in which emotional or associative subject matter was expressed in abstract language, and

he deemphasized works that explored purely formal or, to use Goodrich's term, "escapist" concerns. It was apparent to anyone who read titles and looked closely that even the most nonobjective works in *Advancing American Art* claimed some links with the external world. If *Advancing American Art* is examined within this conceptual framework, it appears that Davidson was attempting to convey with abstract painting the same message implied by his choice of Expressionist and Social Realist works—which was that if art reflected national attitudes, then the United States was a nation of culturally sophisticated yet humanely concerned people.

That the abstract possibilities of early twentieth century Fauve painting were being explored on new levels was apparent in the paintings of Milton Avery and George Constant, neither of whom repudiated figuration in their search for independently expressive form and color. Constant was a sort of abstract humanist who exhibited frequently in museum shows as well as at New York galleries. Until the mid forties, when his work became completely nonrepresentational, Constant's paintings were semi-abstract. Generally devoid of anecdotal allusions, they often portrayed vignettes of human feeling or whimsical aspects of nature, even when structure and color worked independently of recognizable content. He frequently placed figures in interior or landscape settings and through subtle arrangements suggested a mood or emotion that belied the simplicity of his compositions. With the mundane subjects of the *Rock Crabs,* (Fig. 27), the playful, tumbling clumsiness of the archaic beasts was part subject and part excuse for deftly applied paint. Although Weisgall called him a neo-impressionist, Constant assimilated broader sources. Matisse's Fauvist paintings, Modigliani's evocative Cubist forms, and Gauguin's linear primitivism all shaped Constant's aesthetic choices.

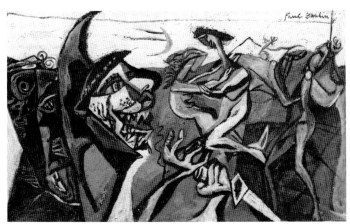

FIG. 22 (no. 11) Paul Burlin *News from Home,* 1944

FIG. 23 (no. 68) Everett Spruce *Owl on Rocks,* 1945

FIG. 24 (no. 72) Max Weber *Two Vases,* 1945

FIG. 25 (no. 61) Abraham Rattner *Bird Bath*

The physical resemblances between many of Constant's paintings and those of Milton Avery derived not only from shared affection for Fauve color but also from their mutual reliance on observed reality to supply thematic motifs. Although primarily concerned with aesthetic organization—the poise of dramatically simplified forms and dense, saturated color—Avery, too, often explored themes of subtle, evocative, and sometimes humorous nuance. The brushy tails and staring eyes of his *Fish Basket*'s stubby occupants cannot be read simply as formalist experiments.

Less directly referential, paintings by Stuart Davis and George L. K. Morris also retained strong imagistic links with visual experience, a quality Davidson may well have considered particularly "American." John R. Lane, for example, describes Davis as an "eloquent proponent of the tradition of realism in late Cubism."[44] A Marxist in the mid thirties and an active member of the American Artists' Congress, Davis struggled for a number of years with the problem of interpreting meaningful experience within a Cubist stylistic format. By the mid forties he had become increasingly concerned with "aesthetic emotion," the evocation of a

mood through pure form and color. But his paintings that Davidson selected for *Advancing American Art* were earlier works, created while Davis was directly concerned with translating American subject matter into an abstract idiom. Both *Trees and El* (Pl. 7) of 1931 and *Shapes of Landscape* (Fig. 26) from 1939 relate to sketches Davis had made of New York and Gloucester respectively, rather than to the more formally-oriented paintings of the mid forties.

Davis had become friendly with Piet Mondrian shortly after the Dutch artist's arrival in New York in 1940. While admiring the man, Davis had difficulty

FIG. 26 (no. 18) Stuart Davis *Shapes of Landscape,* 1939

FIG. 27 (no. 12) George Constant *Rock Crabs*

with what he viewed as the elitism of Mondrian's approach to painting. Prior to his own conversion to issues of "pure aesthetic emotion," Davis had criticized Mondrian and other geometric abstractionists for seeking meaning in form and color alone, without recognizing the dynamic potential of the human spirit.[45]

Many of those Davis criticized were affiliated with American Abstract Artists, a group formed in 1936 by painters and sculptors who felt critics belittled and museums ignored this important facet of American art. The response that often greeted abstract works justified their perceptions. When the

Museum of Modern Art announced the purchase in 1943 of Piet Mondrian's *Broadway Boogie-Woogie,* Howard Devree of the *New York Times* dared dismiss the painting as simply a colorful bathroom tile design. Some members of American Abstract Artists, including Ilya Bolotowsky and Burgoyne Diller, explored pure aesthetic emotion through the balance of geometric and color relationships in the vein of Mondrian, and the eminent Dutchman himself wrote for the group's publications and exhibited in several of their shows. Others investigated more strongly thematic concerns in their paintings. George L. K. Morris, a major spokesman for American Abstract Artists,

probed issues in his work not altogether different from those of Stuart Davis. Although Morris's more completely abstract work was perhaps better known, Davidson selected for *Advancing American Art* a painting entitled *New England Church* (Pl. 8) that was based on emblematic references, not only to textures, hymns, and ecclesiastical architecture, but also, in the tick-tack-toe forms, to the pastimes boredom breeds. Morris was conscious of the importance of European influences in his work and in that of his fellow American Abstract Artists, but he insisted that "the tone and color contrasts [in nonobjective American

FIG. 28 (no. 59) Irene Rice Pereira *Composition,* 1945

painting] are quite native, that the cumulative rhythmic organization resounds from an accent which could have originated in America alone."[46]

If native influences could not be attributed to all the abstract paintings in the exhibition (excepting I. Rice Pereira's *Composition* (Fig. 28) perhaps), most of them maintained at least an ostensible link with nature. Loren MacIver's *Blue Landscape,* (Fig. 30), Karl Knath's *Clam Diggers,* (Fig. 29), and even Bryon Browne's *Still Life in Red, Yellow, and Green,* (Fig. 31), all transformed European stylistic formats into concrete or landscape references. None, however, represented pure abstraction.

Curiously, several of the most nonobjective paintings in *Advancing American Art* were tied directly to the artists' experiences of war. Werner Drewes, a member of American Abstract Artists who had been born in Germany and studied architecture at the Bauhaus in Dessau, was represented in the State Department show by *Gaiety in Times of Distress,* (Fig. 32), a painting that through color and forms suggests the tensions underlying his theme. Similarly, Ralston Crawford's *Plane Production* (Fig. 33) and *Wing Fabrication* (Pl. 11) grew out of his experiences in the U.S. Army's Weather Division. A draftee, Crawford was assigned to making weather maps for use by bomber pilots during the war, and his 1944 exhibition at the Downtown Gallery featured a series of schematic paintings related to this work. The paintings selected for *Advancing American Art* fused the crisp, pristine manner of Crawford's Precisionist paintings with diagrammatic abstract forms drawn from military construction.

Of the remaining abstract artists in the exhibition, William Baziotes, Robert Motherwell, and Adolph Gottlieb represented perhaps Davidson's greatest risks. By 1942 both Motherwell and Baziotes, along with Chilean Surrealist

Roberto Matta Echaurren, were actively discussing the merits of psychic automatism. Based on Jungian concepts of man's unconscious, psychic automatism had emerged in Surrealist precepts as a way to externalize emotions and to express in pictorial language the turmoil of inner conflict. Dissatisfied with doctrinaire Surrealism, the three painters attempted in 1941 to form a group that would use this principle to unmask Surrealist dogmatism. Although the group never coalesced, psychic automatism remained central to the work of both Americans. Baziotes, particularly, could be called a "stream of unconsciousness" painter, because he began each work by doodling in line or color areas, and then through intuition he pursued the possibilities presented by his unconscious. An avid reader of Baudelaire and Symbolist poetry, Baziotes also embedded obscure symbols in his work that, for him, often suggested threatening psychic experiences. Superficially lyrical, many paintings bore titles such as *Flesh Eaters* and *Vampire* that implied ominous creatures removed from reality by myth and distance in time. Although in some cases primordial references became metaphors for evil and fear, they could also allude to life and regeneration.[47] In *Flower Head*, (Pl. 12) for example, the softly modeled color areas and gently rounded petal forms imply the lush richness of a primeval forest.

More directly symbolic, Gottlieb's *Night Passage* (Pl. 13) and *The Couple* clearly contained mythic and primitive forms. About these, as about other of his pictographs, however, Gottlieb insisted that the symbols had no referents beyond the paintings themselves. Instead, as Robert C. Hobbs observes, Gottlieb wanted to give the semblance of meaning using forms that could not be decoded in narrative or intellectual terms.[48] He offered nonexplicit yet strangely familiar emblems that resonate within the unconscious, sounding

atavistic and sensate rather than rational chords.

Having bypassed the pure geometric abstractionists and the Surrealists (who were often viewed as frivolous), Davidson presented both introspective and externally linked abstract paintings. His nonobjective selections, as well as his expressionist and figurative choices, intimated that the work of American artists and the culture it reflected embodied the ultimate democratic values—independence, concern for one's fellow man, and absolute freedom to express individual as well as national concerns.

When *Advancing American Art* was cancelled in the spring of 1947, Edward Alden Jewell, the conservative senior critic for the *New York Times*, wrote that a "cultural crisis" had taken place. Peyton Boswell, *Art Digest*'s esteemed editor, called the situation "tragic" and mentioned the "deadly parallel" with Hitler's Germany and Stalin's Russia. The fundamental tenets of democracy had been subverted.[49]

In organizing *Advancing American Art,* J. LeRoy Davidson had been acutely conscious of the public relations character of his project, and he was sensitive to his audience's eagerness to see for itself the cultural side of this new world power. By denying localism and insular, chauvinistic themes, and emphasizing Expressionist and abstract paintings with strong stylistic ties to Europe, Davidson had painted a picture himself—of the United States as a nation in which artists could freely explore their deep feelings for mankind and, as Ralph Pearson wrote, "delve into the psychological . . . internal, rather than [merely] external realities."[50]

Yet Davidson was also conscious of presenting a responsibly balanced exhibition. He chose figurative painters who could justifiably be considered contemporary American masters; he

presented Expressionists with widely differing philosophical beliefs, and he hinted that even abstract artists worked within a philosophical realm of humanism and objective reality that represented a concern for, rather than a flight from, the troubling issues of contemporary civilization. That his efforts were successful in the mind of his European audience was demonstrated by an ironic twist of timing. As congressional and State Department officials determined to close *Advancing American Art,* the president of Czechoslovakia was arranging for his government to pay the costs of expanding its tour.

At bottom, however, Davidson aligned the United States with the concept of artistic radicalism. To Davidson's opponents, paintings with strong biases toward German and French avant-garde stylistic forms represented a blatant attempt to "uproot all that we have cherished as sacred in the American way of life."[51] To Davidson they suggested that new and innovative possibilities were opening up in America. The optimistic view of American life that graced post office walls around the country no longer described contemporary artistic thought.

NOTES

I would like to thank Linda Johnson, National Museum of American Art 1983 summer intern, for her invaluable assistance in researching the multi-faceted context in which *Advancing American Art* was staged.

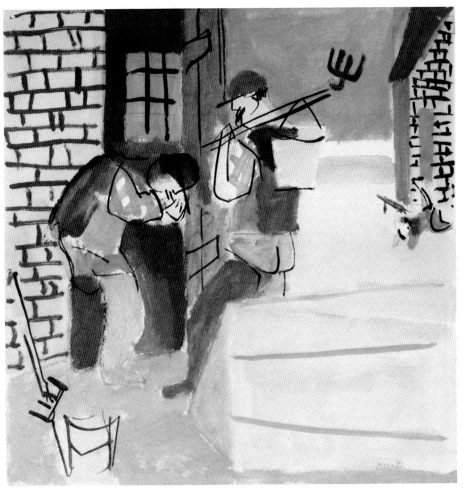

FIG. 29 (no. 44) Karl Knaths *Clam Diggers*

1. In *The Reluctant Patron: The United States Government and the Arts, 1943-1965* (Philadelphia: University of Pennsylvania Press, 1983), 25-32, Gary O. Larson presents a fascinating discussion of the political and public response to the State Department exhibition.

2. In his regular editorial entitled "Comments," *Art Digest* editor Peyton Boswell discussed *Advancing American Art* and the reactions it elicited during the course of the controversy, and he quoted the *Baltimore American* statement. "Humor on the Right," *Art Digest* 21 (October 15, 1946): 3. The *New York Journal-American* caption was cited by Ralph M. Pearson, "Hearst, the A.A.P.L., and Life," *Art Digest* 21 (December 15, 1946): 13.

3. Jane DeHart Mathews, "Art and Politics in Cold War America," *The American Historical Review* 81 (October 1976): 762-787, analyzes political responses to art during the years following World War II.

4. "Round Table," *Magazine of Art* 39 (November 1946) (Unpaginated advertisement). Round Table members included Daniel Catton Rich, David E. Finley, Howard Hanson, Albert Harkness, Archibald MacLeish, Henry A. Moe, Hudson D. Walker, Charles Child, and Rene d'Harnoncourt.

5. William Benton, "Vernissage: Advancing American Art," *Art News* 45 (October 1946): 19.

6. In *The Reluctant Patron* Larson presents a fascinating discussion of the various congressional bills proposing the formation of permanent federal art agencies.

7. When originally established, the Treasury Department program was called the Section of Painting and Sculpture. Several administrative reorganizations, however, resulted in changes in name and in the sponsoring bureau. Histories of the program itself can be found in Richard D. McKinzie, *The New Deal for Artists* (Princeton: Princeton University Press, 1973), and in Virginia M. Mecklenburg, *The Public as Patron* (College Park: University of Maryland Art Gallery, 1979). In *Wall-to-Wall America* (Minneapolis: University of Minnesota Press, 1982), Karal Ann Marling presents an analysis of the social impact and iconography of the post office murals.

8. Mecklenburg, *Public as Patron*, 70-71.

9. Marling, *Wall-to-Wall America,* 174-182, and Mecklenburg, *Public as Patron,* 88-89.

10. Apart from scenes of "past and present" history, a number of the murals depicted some aspect of postal history or mail delivery, often highlighting local events, as in Dorothea Mierisch's McLeansboro, Illinois, mural celebrating the town's first official airmail flight. Americans at work was another popular theme, often shown in terms of agricultural production, lumbering, etc.

11. Marling, *Wall-to-Wall America,* 95-104, discusses the Corning, Iowa, mural at length.

12. In several instances government and industry joined forces. Abbott Laboratories of Chicago, for example, commissioned thirty-six paintings by American artists to be reproduced as posters and also to tour the country under the auspices of the Treasury Department. It was an "Art for Bonds" program in which the museums showing the paintings sold war bonds. Each museum fulfilling a sales quota received one of the paintings from the group.

Artists and their associations also supported the war effort. In New York City an organization entitled Artists for Victory was formed. An association of over thirty existing artists' groups, the Artists for Victory held exhibitions to raise money for war relief. The first show was held in 1942 at the Metropolitan Museum. Earlier the same year Artists for Victory also sent a "Good Will Art Exhibition" of about two hundred paintings, sculptures, and prints by as many artists on a tour through the British Isles.

13. Walter Abell, "Industry and Painting," *Magazine of Art* 39 (March 1946): 84.

14. Abell, "Industry and Painting," 92, 86.

15. Abell, "Industry and Painting," 90, reported in 1946, for example, that

FIG. 30 (no. 52) Loren MacIver *Blue Landscape,* 1940

FIG. 31 (no. 9) Byron Browne *Still Life in Red, Yellow, and Green*, 1945

Stuart Davis's *Terminal* went out on six hundred thousand Pepsi calendars. Oddly the primary reservations Abell expressed about these programs focused not on the prostitution of fine arts images for propagandistic purposes but rather concern that American culture would fall under the control of business. He wrote that "there remain fewer and fewer means through which the social will and the cultural impulse of the American people can freely formulate themselves, independent of all industrial bias. In a society faced with acute economic and social problems—problems which are not likely to be solved without strong opposition between conflicting interests—the potential dangers of an industry-controlled rather than a community-controlled culture are obvious." Abell, "Industry and Painting," 118. A plethora of articles from these years dealt with the issue of business versus community art sponsorship. For an alternate attitude on industrial patronage to Abell's, see Walter S. Mack, Jr., "Viewpoints: A new Step in Art Patronage," *Magazine of Art* 37 (October 1944): 228.

16. The IBM collection started in 1937. Encyclopaedia Britannica began a collection in 1943 that went on a five-year tour of U.S. museums the following spring, accompanied by a

FIG. 32 (no. 27) Werner Drewes *Gaiety in Times of Distress,* 1943

fully illustrated catalogue. Abbott Laboratories commissioned artists to do series of paintings on war (including Thomas Hart Benton's *Year of Peril* series), and also sponsored five war-recording projects in addition to the "Art for Bonds" program. In 1944 the Pepsi-Cola Company inaugurated a series of competitions and exhibitions, entitled "Portrait of America," designed to select art for reproduction in its calendars. Although the title was used for the first two competitions, it was subsequently dropped in order to encourage the submission of all outstanding art, not simply native imagery. The Container Corporation of America and lesser known businesses (Orbach's retail merchandising house in New York among them) also began to commission or purchase art. The N. W. Ayer & Son advertising agency helped pioneer several of these programs, while the Associated American Artists group, founded by Reeves Lowenthal in 1934 to distribute fine prints at popular prices, served as a consultant for others.

17. See "Sixty Americans Since 1800," *Art News* 45 (December 1946): 30-39. In 1937 International Business Machines Corporation had begun collecting paintings (and later sculpture) from the seventy-nine countries where the firm had representatives. The response was so positive that a collection

of work from the United States was begun. Both were shown at the 1939 world's fairs in New York and San Francisco and subsequently traveled throughout the Western Hemisphere. When the State Department received a request from the *Société des Amis d'Art* in Cairo for an exhibition of nineteenth and twentieth century American painting, the collection that was immediately available and suitable was the one formed by IBM.

FIG. 33 (no. 14) Ralston Crawford *Plane Production*

18. Alfred Frankfurter, "American Art Abroad: The State Department's Collection," *Art News* 45 (October 1946): 20-31.

19. A number of art critics and aesthetic theorists at the turn of the century wrote about the social relevance of art for American life. Some, including Charles Caffin, discussed art as a specific tool for the improvement of material existence, while others believed more generally that artists inevitably and unconsciously transmitted atavistic and cultural attitudes in their paint-

ings. It is not unusual to see paintings discussed in terms of native pioneer values, for example.

20. C. J. Bulliett, "Encyclopaedia Britannica Unveils Its Collection of American Art," *Art Digest* 19 (April 1, 1945): 23.

21. Robert Goldwater, "Abraham Rattner: An American Internationalist at Home," *Art in America* 33 (April 1945): 84.

22. Hugo Weisgall, *Advancing American Art* (Prague: U.S. Information Agency, 1947) (unpaginated).

23. H. W. Janson, "Benton and Wood, Champions of Regionalism," *Magazine of Art* 39 (May 1946): 184-186, 198-200.

24. James Thrall Soby, *Romantic Painting in America* (New York: Museum of Modern Art, 1943), 45.

25. Mathews, "Art and Politics," 762. Although Mathews's discussion focuses on the later forties and early fifties, each of the reasons she has identified as basic to charges of communist infiltration directly reflect the opposition to *Advancing American Art* as well. Ironically, the charge that the depiction of social flaws in paintings indicated undemocratic attitudes on the part of the artists directly contradicted Chief Justice Harlan Stone's thematic suggestions for the murals in the Justice Department. When the mural's subject matter was determined in 1934, he specifically requested paintings that contrasted society's less happy aspects with the beautiful and fulfilled life possible under the law. Although the message was heavy-handed, it was consummately important to Stone that the negative side of society be shown in appropriately disgraceful terms.

26. The Artists' Union was formed in 1934 to advocate federal support for artists. The American Artists' Congress was established in 1936 to oppose fascism and war. Many of its members,

including Stuart Davis, were active political Marxists, and the group also had a vociferous communist contingent. In 1940 the Artists' Congress split over support for relief to victims of the Russo-Finnish war. Many members resigned over the defeat at the hands of the communist faction of the relief proposal. Others, dissatisfied generally at what they considered overpoliticization of an artistic association, seceded and formed the nonpolitical Federation of Modern Painters and Sculptors.

27. John I. H. Baur, *Philip Evergood* (New York: Praeger Publishers for the Whitney Museum of American Art, 1960), 55.

28. Weisgall, *Advancing American Art* (unpaginated).

29. Quoted in Piri Halasz, *Directions, Concerns, and Critical Perceptions of Paintings Exhibited in New York, 1940-1949: Abraham Rattner and His Contemporaries* (Ph.D. diss., Columbia University, 1982), 234.

30. Halasz, *Directions, Concerns, and Critical Perceptions,* 233. The most perceptive and comprehensive analyses of the American artistic climate during the forties can be found in Halasz's dissertation and in her articles "Figuration in the Forties: The Other Expressionism," *Art in America* 70 (December 1982): 111-119, 145-147; "Art Criticism (and Art History) in New York: The 1940s Vs. the 1980s," Part I ("The Newspapers"), *Arts* 57 (February 1983): 91-97, and Part 2 ("The Magazines"), *Arts* 57 (March 1983): 64-73.

31. Samuel Kootz, *New Frontiers in American Painting* (New York: Hastings House Publishers, 1943), 53-54.

32. Quoted in John I. H. Baur, *George Grosz* (New York: The MacMillan Company for the Whitney Museum of American Art, 1954), 17.

33. Quoted in Hilton Kramer, "Europe Between the Wars," *New York Times,* September 12, 1971.

34. Quoted in Baur, *George Grosz,* 27.

35. Burlin quoted in Irving Sandler, *Paul Burlin* (New York: American Federation of Art, 1962), 7.

36. Paul Burlin, statement, Downtown Gallery exhibition catalogue, New York 1946, np.

37. During the period from 1931, when the Wadsworth Atheneum in Hartford, Connecticut, showed the first

FIG. 34 (no. 30) Adolph Gottlieb *The Couple,* 1946

Surrealist group exhibition in the United States, and 1947, when the Art Institute of Chicago held a specialized "annual" called *Abstract and Surrealist American Art,* a number of exhibitions introduced the American public to Surrealism. In 1944 the San Francisco Museum of Art traveled a Surrealist exhibition based on Sidney Janis's book, *Abstract and Surrealist Art in America,* to Cincinnati, Denver, Seattle, Portland, Santa Barbara, and Mortimer Brandt's gallery in New York City. For an in-depth study, see Jeffrey Wechsler,

Surrealism and American Art, 1931-1947 (New Brunswick, New Jersey: Rutgers University Art Gallery, 1976).

38. Quoted in Halasz, *Directions, Concerns, and Critical Perceptions, 399.*

39. Quoted in Halasz, *Directions, Concerns, and Critical Perceptions, 338.*

40. A. E. Gallatin's collection included Picasso's *Three Musicians,* Fernand Léger's *The City,* and Joan Miró's *Dog Barking at the Moon,* as well as works by Matisse, Braque, Gris, Arp, Klee, Delaunay, Duchamp, Mondrian, and Americans Karl Knaths, Man Ray, George L. K. Morris, Demuth, and Marin, and others. Although much of Gallatin's collection had been on view in a study room at New York University since the late twenties, in 1942 the university's chancellor declared that the institution could no longer provide a home for the paintings and sculpture. The Philadelphia Museum of Art immediately jumped to the rescue, initially putting the exhibition on view in its entirety and subsequently integrating Gallatin's works with the museum's permanent collection, where they remained following Gallatin's death.

41. Paul Rosenberg, Picasso's dealer in Paris, fled to New York and opened a gallery in 1941. Valentine Dudensing had been showing vanguard abstraction along with less progressive American paintings for a number of years, and Peggy Guggenheim opened her Art of This Century gallery in 1942 with an exhibition of abstract and Surrealist paintings from her own collection. Many of Europe's leading abstract and Surrealist artists had also fled the war to the U.S. Mondrian, the American born Lyonel Feininger, Laszlo Moholy-Nagy, Amadée Ozenfant, Fernand Léger, Naum Gabo, as well as Dali, Max Ernst, Kurt Seligmann, and André Masson had also arrived by the early forties.

42. Rosamund Frost, *Contemporary Art, the March of Art from Cézenne until Now* (New York: Crown Publishers, 1942), 9.

43. Lloyd Goodrich, *Pioneers of Modern Art in America* (New York: Whitney Museum of American Art, 1943), 17.

44. John R. Lane, *Stuart Davis, Art and Art Theory* (New York: The Brooklyn Museum, 1978), 36.

45. Lane, *Stuart Davis,* 35.

46. George L. K. Morris, "The American Abstract Artists," *American Abstract Artists, Three Yearbooks (1938, 1939, 1946),* (New York: Arno Press, 1969), 89.

47. For an in-depth analysis of Baziotes's references, see essays by Barbara Cavaliere and Mona Hadler in *William Baziotes: A Restrospective Exhibition* (Newport Beach, California: Newport Harbor Art Museum, 1978).

48. Robert C. Hobbs and Gail Levin, *Abstract Expressionism: The Formative Years* (Ithaca, New York: The Herbert F. Johnson Museum, 1978), 75-76.

49. Edward Alden Jewell was quoted by Ralph M. Pearson, "A Modern Viewpoint: Cultural Crises," *Art Digest* 22 (May 1, 1947): 29. Peyton Boswell, "Comments," *Art Digest* 22 (May 1, 1947): 7.

50. Ralph M. Pearson, "State Department Exhibition for Foreign Tour," *Art Digest* 21 (October 15, 1946): 29.

51. Congressman Fred Busbey, quoted in Larson, *The Reluctant Patron,* 29.

PLATE VIII (no. 55) George L. K. Morris *New England Church*, 1935-36

66

FIG. 35 (no. 24) Arthur Dove *Another Arrangement,* 1944

Dimensions are in inches followed by centimeters, height precedes width.

Catalogue of the Exhibition

1. **Milton Avery** (American, 1893-1965)

 Summer Morning
 Ink, watercolor, and chalk on board
 21 3/4 × 29 3/4 (55.2 × 75.6 cm.)
 Signed, "Milton Avery 1945" lower right
 1945

 Exhibitions: *Advancing American Art,* 1946-47; U.S.
 Information Service (USIS) Exhibition, Moscow, 1950s.
 References: Bonnie Lee Grad, *Milton Avery* (Royal Oak,
 Michigan, 1981); Cheryl Brutran, *Milton Avery Works on
 Paper* (Williamstown, Massachusetts, 1980).
 Collection of the U.S. Information Agency, Washington,
 D.C.

2. **William Baziotes** (American, 1912-1963)

 Flower Head
 Oil on canvas
 26 × 42 (66 × 106.7 cm.)
 Signed, "Flower Head William Baziotes" upper left
 No date

 Exhibitions: *Advancing American Art,* 1946-47; *Twenty-fifth
 Anniversary Exhibition,* Joslyn Art Museum, Omaha,
 Nebraska, 11/29/56 — 1/2/57.
 Collection of Museum of Art, University of Oklahoma

3. **Gifford Beal** (American, 1879-1956)

 Figures
 Watercolor on paper
 10 × 16 3/4 (25.4 × 43.5 cm.)
 Signed, "Gifford Beal" right of lower center
 No date

 Exhibitions: *Advancing American Art,* 1946-47.
 Collection of Museum of Art, University of Oklahoma

4. **Romare Bearden** (American, born 1914)

 At Five in the Afternoon
 Oil on composition board
 30 × 38 (76.2 × 96.5 cm.)
 Signed, "Bearden" upper right
 1946

 Exhibitions: *Advancing American Art,* 1946-47; *The Loan
 Collection for the Vice President's Residence, Vice President
 Walter Mondale,* organized by the Dallas Museum of Fine
 Arts, Dallas, Texas, 3/1/79 — 3/31/79.
 Collection of Museum of Art, University of Oklahoma

5. **Romare Bearden** (American, born 1914)

 Mad Carousel
 Watercolor on paper
 22 1/2 × 30 3/4 (57.2 × 78.1 cm.)
 Signed, "Bearden" lower left
 No date

 Exhibitions: *Advancing American Art,* 1946-47.
 Collection of Auburn University

6. **Ben-Zion** (American, born Russia; 1897)

 Perpetual Destructor
 Oil on canvas
 26 × 37 (66 × 94 cm.)
 Signed, "Ben-Zion" lower right
 No date

 Exhibitions: *Advancing American Art,* 1946-47.
 Collection of Henry Art Gallery, University of Washington
 War Assets Collection

7. **Ben-Zion** (American, born Russia; 1897)

 Thistles
 Watercolor on paper
 23 × 17 (57.4 × 43.2 cm.)
 Signed, "Ben-Zion" lower right
 No date

 Exhibitions: *Advancing American Art,* 1946-47.
 Collection of New York Mills Union Free School District,
 New York Mills, New York

8. **Louis Bouché** (American, 1896-1969)

 Gallery K
 Oil on canvas
 20 × 23 (50.8 × 57.4 cm.)
 Signed, "Louis Bouché" lower left
 No date

PLATE IX (no. 43) Charles Howard *The Medusa*, 1946

PLATE X (no. 25) Arthur Dove *Grey Greens,* 1942

Exhibitions: *Advancing American Art*, 1946-47.
Collection of Museum of Art, University of Oklahoma

9. **Byron Browne** (American, 1907-1961)

 Still Life in Red, Yellow, and Green
 Oil on canvas
 23 3/4 × 28 (60.3 × 71.1 cm.)
 Signed, "Byron Browne" lower center
 1945

 Exhibitions: *Advancing American Art*, 1946-47.
 Collection of Auburn University

10. **Charles Burchfield** (American, 1893-1967)

 In the Deep Woods
 Watercolor on paper
 29 7/8 × 37 7/8 (75.9 × 96.2 cm.)
 Signed, "Charles Burchfield, 1918" lower right
 1918

 Exhibitions: *Advancing American Art*, 1946-47.
 Collection of Owego Apalachin Central School District,
 Owego, New York

11. **Paul Burlin** (American, 1886-1969)

 News from Home
 Oil on canvas
 23 × 29 (57.4 × 73.7 cm.)
 Signed, "Paul Burlin" upper right
 1944

 Exhibitions: *Advancing American Art*, 1946-47.
 Collection of Auburn University

12. **George Constant** (American, born Greece; 1892-1978)

 Rock Crabs
 Oil on canvas
 20 × 16 (50.8 × 40.6 cm.)
 Signed, "G. Constant" lower right
 No date

 Exhibitions: *Advancing American Art*, 1946-47.
 Collection of Auburn University

13. **George Constant** (American, born Greece; 1892-1978)

 Seated Figure
 Watercolor on paper
 12 × 7 1/4 (30.4 × 18.4 cm.)
 Signed, "G. Constant" lower left
 No date

 Exhibitions: *Advancing American Art*, 1946-47.
 Collection of Auburn University

14. **Ralston Crawford** (American, 1906-1978)

 Plane Production
 Oil on canvas
 28 1/8 × 36 1/4 (71.4 × 92.1 cm.)
 Signed, "©Ralston Crawford" lower left
 No date

 Exhibitions: *Advancing American Art*, 1946-47; *An
 Exhibition of British and American Paintings*, Union
 Gallery, Auburn University, 4/11/76 — 4/30/76.
 Collection of Auburn University

15. **Ralston Crawford** (American, 1906-1978)

 USS Pensacola
 Watercolor on paper
 18 5/8 × 22 1/2 (47.3 × 57.2 cm.)
 Signed, "Ralston Crawford" lower left
 No date

 Exhibitions: *Advancing American Art*, 1946-47.
 Collection of Owego Apalachin Central School District,
 Owego, New York

16. **Ralston Crawford** (American, 1906-1978)

 Wing Fabrication
 Oil on canvas
 30 1/8 × 25 1/8 (76.8 × 63.8 cm.)
 Signed, "©Ralston Crawford" lower left
 1946

 Exhibitions: *Advancing American Art*, 1946-47; *Ralston
 Crawford Retrospective Exhibition*, Tweed Gallery,
 University of Minnesota, Duluth, Minnesota, May 1961.
 Collection of the Museum of Art, University of Oklahoma

17. **Stuart Davis** (American, 1894-1964)

 Impression of the New York World's Fair
 Gouache on board
 14 1/2 × 21 3/4 (36.8 × 55.2 cm.)
 Signed, "Stuart Davis" lower left
 1939

 Exhibitions: *Advancing American Art*, 1946-47; U.S.
 Information Service (USIS) Exhibition, Moscow, 1960s;
 Stuart Davis, Musée D'Art Moderne De La Ville De Paris,
 February 1966.
 References: Commissioned by and first illustrated in
 Harper's Bazaar (February 1939), 60-61.
 Collection of the U.S. Information Agency, Washington,
 D.C.

18. **Stuart Davis** (American, 1894-1964)

 Shapes of Landscape
 Watercolor on paper
 15 × 11 1/2 (38.1 × 29.2 cm.)
 Signed, "Stuart Davis" lower right
 1939

 Exhibitions: *Advancing American Art*, 1946-47.
 Collection of Museum of Art, University of Oklahoma

19. **Stuart Davis** (American, 1894-1964)

 Trees and El
 Oil on canvas
 25 1/8 × 32 (63.8 × 81.3 cm.)
 Signed, "Stuart Davis" lower right
 1931

 Exhibitions: *Advancing American Art,* 1946-47; *Twenty-fifth Anniversary Exhibition,* San Francisco Museum of Art, San Francisco, California, 1960; *Stuart Davis Memorial Exhibition,* National Collection of Fine Arts, Smithsonian Institution, Washington, D.C., 1965; *1931 America: The Artist's View,* Sierra Nevada Museum of Art, Reno, Nevada, 1981-82.

 Collection of Henry Art Gallery, University of Washington War Assets Collection

20. **Julio De Diego** (American, born Spain; 1900-1979)

 Stiff Rearguard Action
 Oil on masonite
 15 3/4 × 22 (40 × 55.9 cm.)
 Signed, "De Diego '42" lower right
 1942

 Exhibitions: *Advancing American Art,* 1946-47.
 Collection of Auburn University

21. **Joseph De Martini** (American, born 1896)

 Monhegan Cliff
 Gouache on board
 11 × 13 1/2 (27.9 × 34.3 cm.)
 Signed, "Joseph De Martini" lower right
 No date

 Exhibitions: *Advancing American Art,* 1946-47.
 Collection of Museum of Art, University of Oklahoma

22. **Joseph De Martini** (American, born 1896)

 The Ravine
 Oil on canvas glued to masonite
 35 1/2 × 27 3/8 (90.2 × 69.5 cm.)
 Signed, "Joseph De Martini" lower right
 No date

 Exhibitions: *Advancing American Art,* 1946-47.
 Collection of Auburn University

23. **Adolf Dehn** (American, 1895-1968)

 Bowery Follies
 Watercolor on wove paper
 15 5/16 × 21 11/16 (38.8 × 55.2 cm.)
 Signed, "Adolf Dehn" lower right
 1946

 Exhibitions: *Advancing American Art,* 1946-47; *Opening Exhibition,* Georgia Museum of Art, The University of Georgia, Athens, Georgia, 11/8/48 — 1/1/49.
 References: *The Eva Underhill Holbrook Memorial Collection of the Georgia Museum of Art* (Athens, Georgia, 1953) 15.
 Collection of Georgia Museum of Art, The University of Georgia, University Purchase, 1948.

FIG. 36 (no. 15) Ralston Crawford *USS Pensacola*

24. **Arthur Dove** (American, 1880-1946)

 Another Arrangement
 Oil on canvas
 26 3/4 × 35 3/4 (67.9 × 90.8 cm.)
 Signed, "Dove" lower center
 1944

 Exhibitions: *Advancing American Art,* 1946-47.
 References: *Fine Arts Collection, Rutgers, The State University* (New Brunswick, New Jersey, 1966); *The Years of Collage* (College Park, Maryland, 1970); Ann Lee Morgan, *Arthur Dove* (1982).
 Collection of The Jane Voorhees Zimmerli Art Museum, Rutgers, The State University, New Brunswick, New Jersey

25. **Arthur Dove** (American, 1880-1946)

 Grey Greens
 Oil on cardboard
 20 × 28 (50.8 × 71.1 cm.)
 Signed, "Dove '42" lower right
 1942

 Exhibitions: *Advancing American Art,* 1946-47; *An Exhibition of British and American Paintings,* Union Gallery, Auburn University, 4/11/76 — 4/30/76.
 Collection of Auburn University

26. **Werner Drewes** (American, born Germany; 1899)

 Balcony
 Oil on canvas
 30 3/16 × 34 1/4 (77.6 × 87 cm.)
 Signed, "Drewes" lower right
 1945

 Exhibitions: *Advancing American Art,* 1946-47.
 Collection of Henry Art Gallery, University of Washington War Assets Collection

PLATE XI (no. 16) Ralston Crawford *Wing Fabrication,* 1946

27. **Werner Drewes** (American, born Germany; 1899)

Gaiety in Times of Distress
Oil on canvas
19 7/8 × 30 (50.5 × 76.2 cm.)
Marked, "4 ⊕ 3" lower left
1943

Exhibitions: *Advancing American Art,* 1946-47.
Collection of Auburn University

28. **Philip Evergood** (American, 1901-1973)

Fascist Leader
Oil on canvas
20 × 25 (50.8 × 63.5 cm.)
Signed, "Philip Evergood '46" lower right
1946

Exhibitions: *Advancing American Art,* 1946-47; *An Exhibition of British and American Paintings,* Union Gallery, Auburn University, 4/11/76 — 4/30/76.
Collection of Auburn University

29. **Lyonel Feininger** (American, 1871-1956)

Late Afternoon
Watercolor and ink on paper
12 1/4 × 18 5/8 (31.1 × 47.3 cm.)
Signed, "Feininger" lower left, "Late Afternoon" lower center, "1934" lower right
1934

Exhibitions: *Advancing American Art,* 1946-47; *An Exhibition of British and American Paintings,* Union Gallery, Auburn University, 4/11/76 — 4/30/76.
Collection of Auburn University

30. **Adolph Gottlieb** (American, 1903-1974)

The Couple
Oil on canvas
25 1/8 × 32 (63.8 × 81.3 cm.)
Signed, "Adolph Gottlieb '46" lower right
1946

Exhibitions: *Advancing American Art,* 1946-47; *Twenty-fifth Anniversary Exhibition,* Joslyn Art Museum, Omaha, Nebraska, 11/29/56 — 1/2/57; *Mid-America Collects,* Oklahoma Art Center, Oklahoma City, Oklahoma, 10/10/77 — 12/10/77.
References: Lawrence Alloway, *Art International,* April 20, 1968, 22.
Collection of Museum of Art, University of Oklahoma

31. **Adolph Gottlieb** (American, 1903-1974)

Night Passage
Gouache on paper
26 × 20 (66 × 50.8 cm.)
Signed, "Adolph Gottlieb '46" right of lower center
1946

Exhibitions: *Advancing American Art,* 1946-47; *Mid-America Collects,* Oklahoma Art Center, Oklahoma City, Oklahoma, 10/10/77 — 12/10/77.
Collection of Museum of Art, University of Oklahoma

32. **William Gropper** (American, 1897-1977)

Home
Oil on canvas
16 1/16 × 20 1/4 (41.1 × 51.4 cm.)
Signed, "Gropper" lower right
No date

Exhibitions: *Advancing American Art,* 1946-47; *An Exhibition of British and American Paintings,* Union Gallery, Auburn University, 4/11/76 — 4/30/76.
Collection of Auburn University

33. **William Gropper** (American, 1897-1977)

Prey
Watercolor on paper
25 1/8 × 14 1/2 (63.8 × 36.8 cm.)
Signed, "Gropper" lower left
No date

Exhibitions: *Advancing American Art,* 1946-47.
Collection of Museum of Art, University of Oklahoma

34. **William Gropper** (American, 1897-1977)

They Fought to the Last Man
Oil on canvas
30 × 40 1/2 (76.2 × 102.9 cm.)
Signed, "Gropper" lower right
No date

Exhibitions: *Advancing American Art,* 1946-47; *Great American Story Tellers,* Oklahoma Art Center, Oklahoma City, Oklahoma, 11/9/79 — 1/13/80.
Collection of Museum of Art, University of Oklahoma

35. **O. Louis Guglielmi** (American, born Egypt; 1906-1956)

Subway Exit
Oil on canvas
29 7/8 × 28 (75.7 × 71 cm.)
Signed, "Guglielmi 1946" lower left
1946

Exhibitions: *Advancing American Art,* 1946-47; *O. Louis Guglielmi, A Retrospective Exhibition,* The Jane Voorhees Zimmerli Art Museum, Rutgers, The State University, New Brunswick, New Jersey, 1980-81.
Collection of Auburn University

36. **O. Louis Guglielmi** (American, born Egypt; 1906-1956)

Tenements
Oil on canvas
36 1/4 × 26 1/8 (92 × 66.3 cm.)
Signed, "Guglielmi/39" lower right
1939

Exhibitions: Downtown Gallery, New York City, 1939; *One Hundred Thirty-Eighth Annual Exhibition of Painting and Sculpture,* Pennsylvania Academy of the Fine Arts, Philadelphia, Pennsylvania, 1/24/43 — 2/28/43; *Advancing American Art,* 1946-47; *Opening Exhibition,* Georgia Museum of Art, The University of Georgia, Athens, Georgia, 11/8/48 — 1/1/49; *Twenty-five Paintings from the Holbrook Collection of the University of*

FIG. 37 (no. 6) Ben-Zion *Perpetual Destructor*

Georgia, Athens, Georgia, Mint Museum, Charlotte, North Carolina, 2/6/49 — 2/27/49; *Dedication Exhibition,* Georgia Museum of Art, The University of Georgia, Athens, Georgia, 1/28/58 — 2/22/58; *Paintings from the Georgia Museum of Art of the University of Georgia,* Washington and Lee University, Lexington, Virginia, April-May, 1960; *Twentieth Anniversary Exhibition,* Georgia Museum of Art, The University of Georgia, Athens, Georgia, 11/8/68 — 12/8/68; *A University Collects: Georgia Museum of Art,* Georgia Museum of Art and The American Federation of Arts, New York City, 1969-1970; *New York, NY,* ACA Galleries, New York City, 3/30/71 — 4/17/71; *Windows and Doors,* Heckscher Museum, Huntington, New York, 1/30/72 — 4/19/72; *Selections from the Collection of the Georgia Museum of Art,* Charles H. MacNider Museum, Mason, Iowa, 6/29/72 — 8/13/72; *O. Louis Guglielmi, A Retrospective Exhibition,* Rutgers University Art Gallery, New Brunswick, New Jersey, 1980-81; *Tenth Anniversary Exhibition,* Charles H. MacNider Museum, Mason City, Iowa, 1/10/76 — 2/15/76.

References: *The Eva Underhill Holbrook Memorial Collection of the Georgia Museum of Art* (Athens, Georgia, 1953) 19; *Georgia Museum of Art: Highlights from the Collection* (Athens, Georgia, 1968); John Baker, *O. Louis Guglielmi, A Retrospective Exhibition* (New Brunswick, New Jersey, 1980) 26-27.

Collection of Georgia Museum of Art, The University of Georgia, University Purchase, 1948

37. **Philip Guston** (American, 1913-1980)

Portrait of Shannah
Oil on canvas
35 1/4 × 21 3/4 (89.5 × 55.2 cm.)
Signed, "Philip Guston, 1941" lower left
1941

Exhibitions: *Advancing American Art,* 1946-47; *Philip Guston,* The University Gallery, University of Minnesota, Duluth, Minnesota, 4/10/50 — 5/12/50; *Forty American Painters 1940-1950,* The University Gallery, University of Minnesota, Duluth, Minnesota, 6/4/51 — 8/30/51; *Ascendancy of American Painting,* Columbia Museum of Art, Columbia, South Carolina, 4/3/63 — 6/2/63; *Washington County Museum of Fine Arts Fiftieth Anniversary Exhibition,* Hagerstown, Maryland, November 1981.

Collection of Washington County Museum of Fine Arts, Hagerstown, Maryland

38. **Robert Gwathmey** (American, born 1903)

Workers on the Land
Oil on canvas
30 1/4 × 40 1/4 (76.8 × 102.2 cm.)
Signed, "Gwathmey '46" lower left
1946

Exhibitions: *Advancing American Art,* 1946-47; *Works from College and University Collections,* American Federation of Arts/U.S. Information Agency, 1956-57 (traveled to Sweden, the Netherlands, Great Britain, Portugal, Spain, France, Germany, and Belgium).

Collection of Museum of Art, University of Oklahoma

39. **Robert Gwathmey** (American, born 1903)

Worksong
Oil on canvas
29 3/4 × 36 (75.6 × 91.4 cm.)
Signed, "Gwathmey '46" upper right
1946

Exhibitions: *Advancing American Art,* 1946-47; *An Exhibition of British and American Paintings,* Union Gallery, Auburn University, 4/11/76 — 4/30/76.

Collection of Auburn University

40. **Marsden Hartley** (American, 1877-1943)

Whale's Jaw, Dogtown (also titled *Split Rock, Dogtown, Glouchester,* or *Whale's Jaw, Dogtown Common, Cape Ann, Massachusetts*)
Oil on academy board
18 × 23 15/16 (45.7 × 60.8 cm.)
No signature
1934

Exhibitions: *Advancing American Art,* 1946-47; *1931 America: The Artist's View,* Sierra Nevada Museum of Art, Reno, Nevada, 1981-82.

Collection of Henry Art Gallery, University of Washington War Assets Collection

41. **Marsden Hartley** (American, 1877-1943)

Wild Sea Rose
Oil on academy board
11 3/4 × 15 3/4 (29.8 × 40 cm.)
Signed "M.H." lower right
No date

Exhibitions: *Advancing American Art,* 1946-47.

Collection of Mr. and Mrs. Stephen A. Seidel,
 Philadelphia, Pennsylvania

42. **Edward Hopper** (American, 1882-1967)

House, Provincetown
Watercolor on paper
20 1/4 × 25 1/2 (51.4 × 64.8 cm.)
Signed, "Edward Hopper Provincetown" lower right
1930

Exhibitions: *Advancing American Art,* 1946-47; *Edward
 Hopper,* University Art Gallery, University of Arizona,
 Tuscon, Arizona, 4/20/63 — 5/19/63; *Edward
 Hopper Retrospective,* Whitney Museum of American Art,
 New York City, 9/29/64 — 11/29/64; *The Colleges
 and Universities Collect,* Arizona State University,
 Flagstaff, Arizona, 5/3/66 — 5/31/66; *American Scene
 Twentieth Century,* Indiana University Art Museum,
 Bloomington, Indiana, 4/5/70 — 5/17/70; *Mid-
 America Collects,* Oklahoma Art Center, Oklahoma City,
 Oklahoma, 10/10/77 — 12/10/77.

Collection of the Museum of Art, University of Oklahoma

43. **Charles Howard** (American, born 1899)

The Medusa
Oil on canvas
14 1/8 × 18 3/16 (35.9 × 47.2 cm.)
Signed, "C.H. 8:VII:46" lower right
1946

Exhibitions: *Advancing American Art,* 1946-47.

Collection of Museum of Art, University of Oklahoma

44. **Karl Knaths** (American, 1891-1971)

Clam Diggers
Watercolor on paper
18 1/4 × 17 3/4 (46.4 × 45.1 cm.)
Signed, "Knaths" lower right
No date

Exhibitions: *Advancing American Art,* 1946-47.

Collection of Auburn University

45. **Walt Kuhn** (American, 1880-1949)

Pine at Five O'Clock
Oil on canvas
30 × 25 (76.2 × 63.5 cm.)
Signed, "Walt Kuhn 1945" lower left
1945

Exhibitions: *Advancing American Art,* 1946-47.

References: *Fine Arts Collection, Rutgers, The State
 University* (New Brunswick, New Jersey, 1966).

Collection of The Jane Voorhees Zimmerli Art Museum,
 Rutgers, The State University, New Brunswick, New
 Jersey

46. **Walt Kuhn** (American, 1880-1949)

Still Life with Bananas
Oil on canvas
26 1/4 × 38 1/4 (66.7 × 97.2 cm.)
Signed, "Walt Kuhn, 1941" lower left
1941

Exhibitions: *Advancing American Art,* 1946-47.

Collection of Owego Apalachin Central School District,
 Owego, New York

47. **Yasuo Kuniyoshi** (American, born Japan; 1889-1953)

Circus Girl Resting
Oil on canvas
39 1/4 × 28 3/4 (99.7 × 73 cm.)
Signed, "Y. Kuniyoshi" lower left
No date

Exhibitions: *Advancing American Art,* 1946-47; *An
 Exhibition of British and American Paintings,* Union
 Gallery, Auburn University, 4/11/76 — 4/30/76.

Collection of Auburn University

48. **Yasuo Kuniyoshi** (American, born Japan; 1889-1953)

Deserted Brickyard
Oil on canvas
20 1/8 × 35 1/4 (51.1 × 89.5 cm.)
Signed, "Yasuo Kuniyoshi, 1938" lower right
1938

Exhibitions: *Advancing American Art,* 1946-47; *Yasuo
 Kuniyoshi 1889-1953, A Retrospective Exhibition,*
 University Art Museum, The University of Texas at
 Austin, 1975.

Collection of Honolulu Academy of Arts, Gift of Philip E.
 Spalding, 1949

49. **Jacob Lawrence** (American, born 1917)

Harlem
Watercolor on paper
28 × 21 (71.1 × 53.3 cm.)
Signed, "Jacob Lawrence 1946" lower right; inscribed,
 "Because of the many unwritten covenants that exist in
 N.Y.C. Decent living quarters come high to thoes [*sic*]
 Harlemites who can afford to pay." lower left
1946

Exhibitions: *Advancing American Art,* 1946-47; *An
 Exhibition of British and American Paintings,* Union
 Gallery, Auburn University, 4/11/76 — 4/30/76.

Collection of Auburn University

76

PLATE XII (no. 2) William Baziotes *Flower Head*

PLATE XIII (no. 31) Adolph Gottlieb *Night Passage*, 1946

FIG. 38 (no. 54) Reginald Marsh *Lifeguards,* 1933

50. **Julian Levi** (American, 1900-1982)

Wasteland Images, Martha's Vineyard
Oil on canvas
16 3/8 × 24 1/8 (41.6 × 61.3 cm.)
Signed, "Julian Levi" lower left
1943

Exhibitions: *Advancing American Art,* 1946-47; *Opening Exhibition,* Georgia Museum of Art, The University of Georgia, Athens, Georgia, 11/8/48 — 1/1/49; *The Eva Underhill Collection of the Georgia Museum of Art,* Athens, Georgia, 1953; *The Alfred Holbrook Collection of American Painting,* Birmingham Museum of Art, Birmingham, Alabama, 12/2/56 — 1/3/57; *Georgia Museum of Art: Dedication Exhibition,* Athens, Georgia, 1/28/58 — 2/22/58.
Collection of Georgia Museum of Art, The University of Georgia, University Purchase, 1948

51. **Jack Levine** (American, born 1915)

Horse
Oil on canvas
30 × 36 (76.2 × 91.4 cm.)
Signed, "J. Levine" upper right
1946

Exhibitions: *Advancing American Art,* 1946-47; *Jack Levine Exhibition,* Institute of Contemporary Art, Boston, Massachusetts, 1952; *Jack Levine Retrospective,* Whitney Museum of American Art, New York City, 1/29/55 — 3/19/55; *Looking at Modern Painting: Fourth Annual Invitational Exhibition,* University of Utah, Salt Lake City, Utah, 3/1/59 — 3/23/59; *Jack Levine Retrospective,* The American Federation of Arts, New York City, July-December 1960; *Directions in Twentieth Century American Painting,* Dallas Museum of Fine Arts, Dallas, Texas, 10/7/61 — 11/12/61; *The Jewish Experience,* The Jewish Museum, New York City, 10/24/75 — 1/25/76; *Expressionism,* Institute of Contemporary Art, Boston, Massachusetts, 1/9/79 — 2/28/79.
Collection of Museum of Art, University of Oklahoma

52. **Loren MacIver** (American, born 1909)

Blue Landscape (also titled *Blue Dunes)*
Oil on canvas
40 × 30 1/8 (101.6 × 76.5 cm.)
Signed, "MacIver" lower right
1940

Exhibitions: *Advancing American Art,* 1946-47; *MacIver-Pereria Exhibition,* Whitney Museum of American Art, New York City, 1/8/53 — 3/1/53; *Thirtieth Anniversary Exhibition,* University of Kansas Museum of Art, Lawrence, Kansas, 2/22/58 — 3/30/58.
Collection of Museum of Art, University of Oklahoma

53. **John Marin** (American, 1870-1953)

Seascape
Oil on canvas
23 1/2 × 30 (59.7 × 76.2 cm.)
Signed, "Marin '40" lower right
1940

Exhibitions: *Advancing American Art,* 1946-47; *An Exhibition of British and American Paintings,* Union Gallery, Auburn University, 4/11/76 — 4/30/76
Collection of Auburn University

54. **Reginald Marsh** (American, 1898-1954)

Lifeguards
Tempera on gessoed masonite panel
35 1/2 × 23 5/8 (90.2 × 60 cm.)
Signed, "Reginald Marsh 1933" lower right

Exhibitions: *Advancing American Art,* 1946-47; *Opening Exhibition,* Georgia Museum of Art, The University of Georgia, Athens, Georgia, 11/8/48 — 1/1/49; *Twenty-five Paintings from the Holbrook Collection of the University of Georgia,* Georgia Museum of Art, The University of Georgia, Athens, Georgia, and the Mint

Museum, Charlotte, North Carolina, 2/6/49 —
2/27/49; *A Century of American Painting*, Rich's
Department Store, Atlanta, Georgia, September 1950;
The Alfred H. Holbrook Collection of American Painting,
Birmingham Museum of Art, Birmingham, Alabama,
12/2/56 — 1/3/57; *Georgia Museum of Art:
Dedication Exhibition*, Georgia Museum of Art, The
University of Georgia, Athens, Georgia, 1/28/58 —
2/22/58; *Masterpieces in Georgia Collections*, Telfair
Academy of Arts and Sciences, Savannah, Georgia,
5/3/58 — 5/18/58; *American College and University
Collections*, The William Hayes Ackland Memorial Art
Center, University of North Carolina, Chapel Hill, North
Carolina, 9/20/58 — 10/20/58; *The Seashore:
Paintings of the Nineteenth and Twentieth Centuries*,
Museum of Art, Carnegie Institute, Pittsburg, Pennsylvania,
10/22/65 — 12/5/65; *East Side-West Side, All
Around the Town: A Retrospective Exhibition of
Paintings, Watercolors, and Drawings by Reginald Marsh*,
The University of Arizona Museum of Art, Tucson,
Arizona, 3/14/69 — 4/13/69; *A University Collects:
Georgia Museum of Art*, Georgia Museum of Art and the
American Federation of Arts, New York City, 1969-70;
Selections from the Collection of the Georgia Museum of Art,
Charles H. MacNider Museum, Mason, Iowa,
6/29/72 —8/13/72; *Reginald Marsch's New York*,
Whitney Museum of American Art, New York City,
6/29/83 —8/21/83.

References: *The Eva Underhill Holbrook Memorial Collection
of the Georgia Museum of Art* (Athens, Georgia, 1953)
26; Gustave van Groschwitz, *The Seashore: Paintings of
the Nineteenth and Twentieth Centuries* (Pittsburg,
Pennsylvania, 1965); *Georgia Museum of Art: Highlights
from the Collection* (Athens, Georgia, 1968); *A University
Collects* (Athens, Georgia, 1969); Edward Laning, *East
Side-West Side All Around the Town: A Retrospective
Exhibition of Paintings, Watercolors, and Drawings by
Reginald Marsh* (Tucson, Arizona, 1969) 28; Gerald
Carson, "Once More on to the Beach," *American
Heritage* August 1971, 1; "Good Investment for the
University of Georgia," *Athens Banner-Herald*, August
16, 1971, 1; "Paintings Seen in Publication," *Columns* I,
August 9, 1971, 3; Lloyd Goodrich, *Reginald Marsh*
(New York City, 1972) 110; Edward Laning, *The
Sketchbooks of Reginald Marsh* (Greenwich, Connecticut,
1973) 61; Matthew Baigell, *The American Scene
Paintings of the 1930s* (New York City, 1974) 147, 156;
Eloise Spaeth, *American Art Museums: An Introduction to
Looking*, 3d ed. (New York City, 1975) 110; Donald T.
and Marilyn K. Lunde, *The Next Generation: A Book on
Parenting* (New York City, 1980).

Collection of Georgia Museum of Art, The University of
Georgia, University Purchase, 1948

Note: Shown only at the National Museum of America
Art, Smithsonian Institution, Washington, D.C.

55. **George L. K. Morris** (American, 1905-1975)

New England Church
Oil on canvas
36 1/8 × 30 (91.7 × 76.2 cm.)
Signed, "Morris" lower right
1935-36

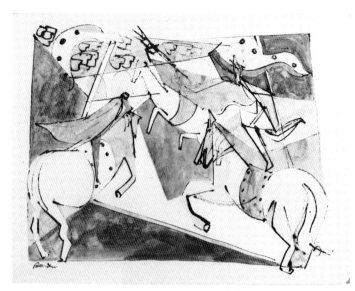

FIG. 39 (no. 5) Romare Bearden *Mad Carousel*

Exhibitions: *Advancing American Art*, 1946-47.
Collection of Museum of Art, University of Oklahoma

56. **Robert Motherwell** (American, born 1915)

Figuration
Tempera on paper
13 1/4 × 9 9/16 (33.7 × 24.3 cm.)
Signed, "Robert Motherwell" lower left
No date

Exhibitions: *Advancing American Art*, 1946-47.
Collection of Henry Art Gallery, University of Washington
 War Assets Collection

57. **Georgia O'Keeffe** (American, born 1887)

Cos Cob
Oil on canvas
16 × 12 (40.6 × 30.5 cm.)
Signed, "Georgia O'Keeffe-Cos Cob 1926" verso, lower
center
1926

Exhibitions: *Advancing American Art*, 1946-47; *O'Keeffe*,
 First State Bank, Abilene, Texas, 9/17/77 — 10/2/77;
 *Georgia O'Keeffe: An Exhibition of Oils, Watercolors, and
 Drawings*, Sheldon Memorial Art Gallery, University of
 Nebraska, Lincoln, Nebraska, 9/9/80 — 10/19/80.
Collection of Museum of Art, University of Oklahoma

58. **Georgia O'Keeffe** (American, born 1887)

Small Hill Near Alcade
Oil on canvas
10 × 24 1/4 (25.4 × 61.6 cm.)
No signature
No date

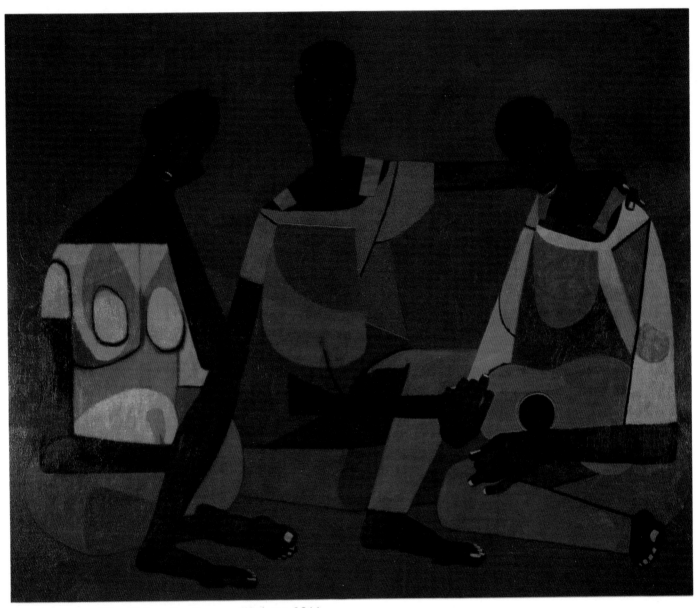

PLATE XIV (no. 39) Robert Gwathmey *Worksong,* 1946

Exhibitions: *Advancing American Art,* 1946-47; *An Exhibition of British and American Paintings,* Union Gallery, Auburn University, 4/11/76 — 4/30/76; *Georgia O'Keeffe: An Exhibition of Oils, Watercolors, and Drawings,* Sheldon Memorial Art Gallery, University of Nebraska, Lincoln, Nebraska, 9/9/80 — 10/19/80.

Collection of Auburn University

59. **Irene Rice Pereira** (American, 1907-1971)

Composition
Ink and gouache on paper
16 × 11 3/4 (40.6 × 29.8 cm.)
Signed, "I. Rice Pereira '45" lower right
1945

Exhibitions: *Advancing American Art,* 1946-47; *An Exhibition of British and American Paintings,* Union Gallery, Auburn University, 4/11/76 — 4/30/76.

Collection of Auburn University

60. **Gregorio Prestopino** (American, born 1907)

Donkey Engine
Gouache on paper
22 5/16 × 29 3/8 (58.3 × 75.2 cm.)
Signed, "Prestopino" lower left
No date

Exhibitions: *Advancing American Art,* 1946-47.

Collection of Auburn University

61. **Abraham Rattner** (American, 1893-1978)

Bird Bath
Watercolor on board
11 3/8 × 15 3/8 (29.5 × 39.7 cm.)
Signed, "Rattner" lower left
No date

Exhibitions: *Advancing American Art,* 1946-47.

Collection of Museum of Art, University of Oklahoma

62. **Anton Refregier** (American, born Russia; 1905)

End of the Conference
Oil on canvas
32 1/8 × 16 (81.6 × 40.6 cm.)
Signed, "A. Refregier 1945" lower right
1945

Exhibitions: *Advancing American Art,* 1946-47; *Great American Story Tellers,* Oklahoma Art Center, Oklahoma City, Oklahoma, 11/9/79 — 1/13/80.

Collection of Museum of Art, University of Oklahoma

63. **Boardman Robinson** (American, born Canada; 1876-1952)

Thomas Rhodes
Gouache on masonite
16 × 12 (40.6 × 30.5 cm.)
Signed, "BR" lower right
No date

Exhibitions: *Advancing American Art,* 1946-47.

Collection of Auburn University

64. **Ben Shahn** (American, born Lithuania; 1899-1969)

The Clinic
Tempera on paper, laid down on masonite
15 5/8 × 22 3/4 (39.7 × 57.8 cm.)
Signed, "Ben Shahn" upper right and "Ben Shahn" lower right
1944-45

Exhibitions: *Advancing American Art,* 1946-47; *Ben Shahn: A Retrospective Exhibition,* State Museum of New Jersey, Trenton, New Jersey, 9/20/69 — 11/6/69; *Ben Shahn,* The National Museum of Modern Art, Tokyo, Japan, 5/21/70 — 7/5/70; *Ben Shahn: A Retrospective 1889-1969,* Jewish Museum, New York City, 10/2/76 — 1/2/77.

References: *The Eva Underhill Holbrook Memorial Collection of The Georgia Museum of Art* (Athens, Georgia, 1953) 31.

Collection of Georgia Museum of Art, The University of Georgia, University Purchase, 1948

65. **Ben Shahn** (American, born Lithuania; 1899-1969)

Hunger
Gouache on composition board
39 × 25 (99.1 × 63.5 cm.)
Signed, "Ben Shahn" lower right
No date

Exhibitions: *Advancing American Art,* 1946-47; *Ben Shahn Retrospective,* Museum of Modern Art, New York City, 9/30/47 — 1/4/48; *American Painting: the 1940s,* American Federation of Arts, New York City, May 1947-May 1948; *Ben Shahn: A Retrospective 1889-1969,* Jewish Museum, New York City, 10/2/76 — 1/2/77; *An Exhibition of British and American Paintings,* Union Gallery, Auburn University, 4/11/76 — 4/30/76.

Collection of Auburn University

66. **Ben Shahn** (American, born Lithuania; 1899-1969)

Renascence
Oil on Whatman hot pressed board
21 7/8 × 30 (55.5 × 76.2 cm.)
Signed, "Ben Shahn" lower right
1946

Exhibitions: *Advancing American Art,* 1946-47; *Ben Shahn Retrospective,* Museum of Modern Art, New York City, 9/30/47 — 1/4/48; *Twenty-fifth Anniversary Exhibition,* Joslyn Art Museum, Omaha, Nebraska, 11/25/56 — 1/2/57; *Thirtieth Anniversary Exhibition,* University of Kansas Museum of Art, Lawrence, Kansas, 2/22/58 — 3/30/58; *The Colleges and Universities Collect,* Arizona State University, Flagstaff, Arizona, 5/3/66 — 5/31/66; *Ben Shahn Retrospective,* Santa Barbara Museum of Art, Santa Barbara, California, 7/31/67 — 9/10/67; *Ben Shahn: A Retrospective Exhibition,* State Museum of New Jersey, Trenton, New Jersey, 9/20/69 — 11/6/69; *Homage to Ben Shahn,* Parco Company, Ltd., and DNP America, Inc., Pensacola Museum of Art, Pensacola, Florida, December 1980-January 1981 (traveled to Tokyo and Sapporo, Japan).

Collection of Museum of Art, University of Oklahoma

67. **Charles Sheeler** (American, 1883-1965)

Boneyard
Oil on canvas
12 × 16 (30.5 × 40.6 cm.)
Signed, "Sheeler '45" lower left
1945

Exhibitions: *Advancing American Art,* 1946-47.

References: *Fine Arts Collection, Rutgers, The State University* (New Brunswick, New Jersey, 1966).

Collection of The Jane Voorhees Zimmerli Art Museum, Rutgers, The State University, New Brunswick, New Jersey

68. **Everett Spruce** (American, born 1907)

Owl on Rocks
Oil on board
16 1/8 × 20 1/16 (40.9 × 51.3 cm.)
Signed, "E. Spruce" lower right
1945

Exhibitions: *Advancing American Art,* 1946-47; *The Eva Underhill Holbrook Memorial Collection of the Georgia Museum of Art,* Athens, Georgia, 1953; *Georgia Museum of Art: Dedication Exhibition,* Georgia Museum of Art, The University of Georgia, Athens, Georgia, 1/28/58 — 2/22/58.

Collection of Georgia Museum of Art, The University of Georgia, University Purchase, 1948

69. **Franklin Watkins** (American, 1894-1972)

Portrait of Old Woman
Oil on canvas
18 × 14 (45.7 × 35.6 cm.)
Signed, "F.W." upper right
No date

Exhibitions: *Advancing American Art,* 1946-47.

Collection of Lancaster County Art Association, Lancaster, Pennsylvania

70. **Max Weber** (American, born Poland; 1881-1961)

Conversation (also titled *Discussion)*
Oil on canvas
23 × 28 1/4 (58.4 × 71.8 cm.)
Signed, "Max Weber" lower right
No date

Exhibitions: *Advancing American Art,* 1946-47.

Collection of Henry Art Gallery, University of Washington War Assets Collection

71. **Max Weber** (American, born Poland; 1881-1961)

Fruit and Wine
Oil on canvas
26 1/4 × 21 (66.7 × 53.3 cm.)
Signed, "Max Weber" lower right
No date

Exhibitions: *Advancing American Art,* 1946-47.

Collection of New York Mills Union Free School District, New York Mills, New York

72. **Max Weber** (American, born Poland; 1881-1961)

Two Vases
Oil on board
21 7/8 × 24 (55.5 × 61 cm.)
Signed, "Max Weber '45" lower right
1945

Exhibitions: *Advancing American Art,* 1946-47; *Twenty-fifth Anniversary Exhibition,* Joslyn Art Museum, Omaha, Nebraska, 11/25/56 — 1/2/57; *Looking at Modern Painting: Fourth Annual Invitational Exhibition,* University of Utah, Salt Lake City, Utah, 3/1/59 — 3/23/59.

Collection of Museum of Art, University of Oklahoma

73. **Karl Zerbe** (American, born Germany; 1903-1972)

Clown and Ass
Oil on canvas (encaustic)
24 × 32 (61 × 81.3 cm.)
Signed, "Zerbe" lower left
No date

Exhibitions: *Advancing American Art,* 1946-47; *An Exhibition of British and American Paintings,* Union Gallery, Auburn University, 4/11/76 — 4/30/76.

Collection of Auburn University

FIG. 40 (no. 45) Walt Kuhn *Pine at Five O'Clock*, 1945

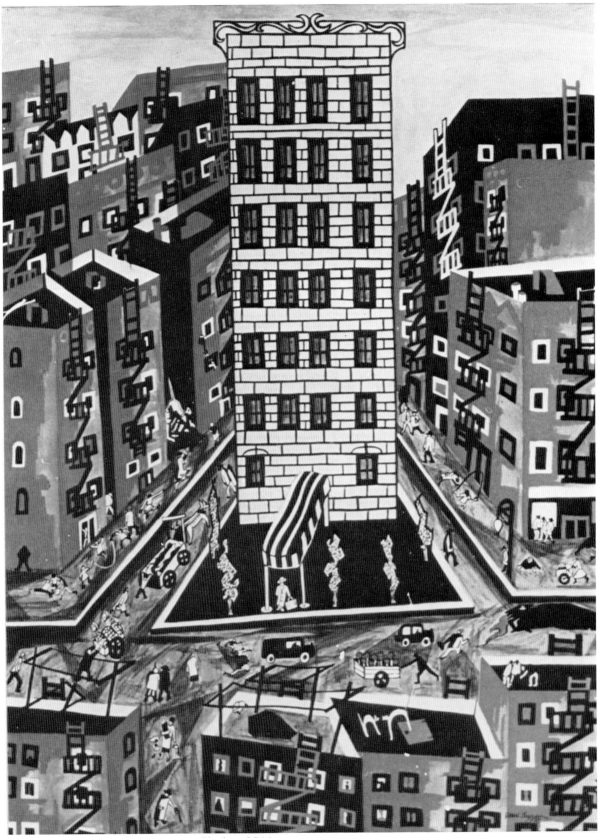

FIG. 41 (no. 49) Jacob Lawrence *Harlem*, 1946

Chronology

1946

January 1, 1946

The Office of International Information and Cultural Affairs within the U.S. State Department was formed by executive order. This office assumed the responsibilities of the Office of War Information, the Coordinator of Inter-American Affairs, and the State Department's own Division of Libraries and Institutes.

May-June 1946

J. LeRoy Davidson bought seventy-nine oils for the collection *Advancing American Art*. Thirty-eight watercolors were purchased by the American Federation of Arts under a contract to supplement the oils.

October 1946

Art News published its special issue, "American Art Aboard," surveying the oil paintings chosen for the *Advancing American Art* collection.

October 4, 1946

An exhibition containing the seventy-nine oil paintings from *Advancing American Art* opened at the Metropolitan Museum in New York.

October 27, 1946

Metropolitan Museum exhibition closed. The paintings were divided into two groups and shipped to Europe and Latin America to begin overseas showings.

November 1946

Forty-nine oils and thirty-five watercolors from *Advancing American Art* were placed on view at the Musée d'Art Moderne in Paris as part of the festivities surrounding the first general conference of UNESCO.

November 6, 1946

Albert Reid, vice president of the American Artists Professional League, AAPL, wrote a letter of protest concerning *Advancing American Art* to Secretary of State James F. Byrnes. He deplored the "radicalism" of the stylistic trends demonstrated in the collection's paintings.

November 19 and 26; December 3, 1946

The Hearst press published full page articles reproducing some of the collection's works in its syndicated newspapers. These articles were direct attacks on *Advancing American Art* and modern painting.

December 20, 1946	*Advancing American Art* closed in Paris. The oils were shipped to Prague, Czechoslovakia, to begin a projected five-year tour. The watercolors traveled to Guatemala.

1947

January 1947	*Art News* named *Advancing American Art* the "most significant modern exhibition of the year 1946."
January 7, 1947	General George C. Marshall was appointed secretary of state, replacing James F. Byrnes.
February 4, 1947	John Taber, chairman of the House Appropriations Committee, wrote Secretary of State Marshall requesting a full account of the *Advancing American Art* project.
February 5 and 7, 1947	Radio commentator Fulton Lewis attacked the collection as a waste of public funds.
February 18, 1947	*Look* magazine reproduced seven of the collection's paintings, informing readers that "your money" bought them.
February 19, 1947	Secretary Marshall replied to Congressman Taber's request for information with a memorandum of justification for the art program.
March 6, 1947	Exhibition of works from the collection opened in Prague, Czechoslovakia. A small catalogue, with essay by Hugo Weisgall, an American national in Prague, was published to accompany the works.
April 2, 1947	President Harry S. Truman wrote to Assistant Secretary Benton his opinion of modern art, characterizing it as "the vaporings of half-baked, lazy people."
April 4, 1947	Secretary Marshall ordered that the paintings be held until further notice in Prague and Port-au-Prince, Haiti, where other works from the *Advancing American Art* collection were shown.
April 16, 1947	An exhibition of Soviet art opened in Prague as a direct response to the popularity *Advancing American Art* was enjoying there.
April 30, 1947	J. LeRoy Davidson resigned as Visual Arts Specialist for the Office of International Information and Cultural Affairs, and the position was abolished.
May 5, 1947	The House Committee on Appropriations recommended the abolition of the State Department's cultural relations programs after hearing testimony by Assistant Secretary Benton regarding the *Advancing American Art* collection.
	A rally was organized by art groups in New York to protest the cut off of funds for *Advancing American Art* and the State Department art program. Speakers at the rally included John D. Morse, editor of the *Magazine of Art;* Edward Alden Jewell, art critic for the *New York Times;* and Edith Halpert, owner of the Downtown Gallery.

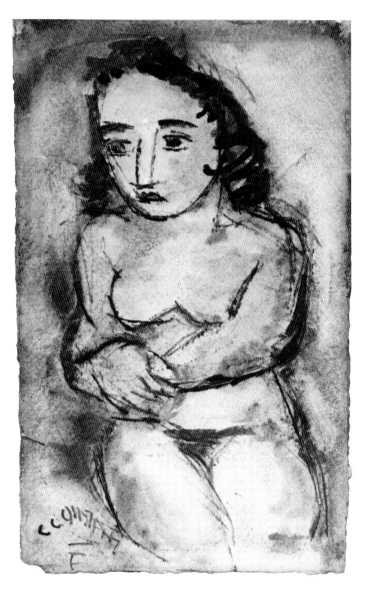

FIG. 42 (no. 13) George Constant *Seated Figure*

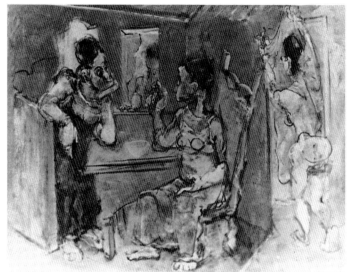

FIG. 43 (no. 70) Max Weber *Conversation*

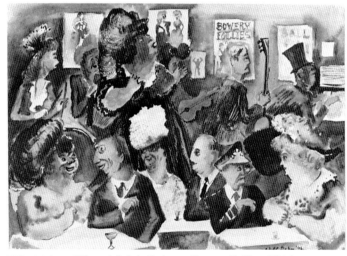

FIG. 44 (no. 23) Adolph Dehn *Bowery Follies*, 1946

FIG. 45 (no. 58) Georgia O'Keeffe *Small Hill Near Alcade*

FIG. 46 (no. 57) Georgia O'Keeffe) *Cos Cob*, 1926

June 9, 1947	John Howe, Assistant Secretary Benton's assistant, recommended that the *Advancing American Art* project be cancelled.
June 11, 1947	A cable signed by Secretary Marshall was sent to Prague and Port-au-Prince ordering the return of the *Advancing American Art* paintings to the United States.
September-October 1947	Staff members of the Office of International Information and Cultural Affairs discussed with members of the art community methods of disposal for the *Advancing American Art* paintings. The legal office at the Department indicated that, by law, the State paintings could all be sold only if categorized as war surplus and turned over to War Assets Administration.
November 28, 1947	The paintings were stored in New York at the Manhattan Storage and Warehouse Company.

1948

May 17, 1948	One hundred and seventeen paintings from the *Advancing American Art* collection were placed on view at the Whitney Museum of American Art prior to their sale by auction by the War Assets Administration.
May 23, 1948	The *New York Times* reported that the paintings were to be auctioned by the War Assets Administration with priority going to educational institutions which would receive a ninety-five percent discount.
June 19, 1948	The bidding for the works closed at 10:00 a.m. a total of 149 bids were received.
June 25, 1948	Completed statistics of the sale were published by the American Federation of Arts. The total value of the collection was listed as $85,000. After discounts to educational institutions, the government realized $5,544.
July 5, 1948	The art column of *Newsweek* referred to the outcome of the sale as "Retired American Art."

FIG. 47 (no. 56) Robert Motherwell *Figuration*

Bibliography

"American Reaction to Art." *Svobodné Noviny*, June 19, 1947.

"Art for Taxpayers." *The Republican News*, August 1947.

"Artists Protest Halting Art Tour." *New York Times*, May 6, 1947, 24.

"Auburn Gets Art Bargain." *Birmingham News*, 1948.

Barr, Alfred M., Jr. "Is Modern Art Communistic?" *New York Times Magazine*. December 14, 1952, 20.

Bear, Donald. Introduction to *Contemporary American Painting, the Encyclopaedia Britannica Collection*. New York: Duell, Sloan and Pearce, 1945.

Benjamin, Ruth. "American Art through Foreign Eyes." *Gazette des Beaux-Arts* 25 (May 1944): 299-314.

Berryman, Florence S. "The State Department's Traveling Exhibition." *American Year Book*, 1947, 974-975.

"Best in U.S. Art? They Find it Crazy." *New York Journal-American*, February 18, 1947.

"Bidders Draw Lots for 'Surplus' Art." *New York Times*, June 22, 1948, 21.

"Bids are Opened for Surplus Art." *New York Times*, June 20, 1948, 22.

Boswell, Peyton. "Humor on the Right." *Art Digest* 21 (October 15, 1946): 3.

⸻. "Killed by Politics." *Art Digest* 21 (May 1, 1947): 7.

⸻. "Sand in the Ostrich's Eye." *Art Digest* 21 (December 1, 1946): 3.

Bulliett, C. J. "Encyclopaedia Britannica Unveils Its Collection of American Art." *Art Digest* 19 (April 1, 1945): 23.

Clapp, Jane. *Art Censorship, A Chronology of Proscribed and Prescribed Art*. Metuchen, N.J.: The Scarecrow Press, 1972.

Clark, Kenneth. "Art and Democracy." *Magazine of Art* 40 (February 1947): 74-79.

Coates, Robert M. "The Art Galleries: The Jury System and Other Problems." *The New Yorker*, October 12, 1946, 74-75.

"Collection of American Art Held Unfair to U.S. Women." *Washington Post*, February 14, 1947, section C, p. 7.

"Controversial Art to be Sold to Bidders Under Guise of U.S. War Surplus Property." *New York Times*, May 18, 1948, 21.

Crane, Jane Watson. "State Department Sends New Type U.S. Art Show Abroad." *Washington Post*, October 27, 1946, 7.

Craven, Thomas. "Is American Art Degraded?" *'48* 2 (June 1948): 66-81.

FIG. 48 (no. 10) Charles Burchfield *In the Deep Woods,* 1918

Crouse, Jack. "Campus Art." *University of Washington Daily,* August 5, 1948.

D'Harnoncourt, Rene. "Challenge and Promise: Modern Art and Modern Society." *Magazine of Art* 41 (November 1948): 250-252.

Davidson, J. LeRoy. "Advancing American Art." *American Foreign Service Journal* 23 (December 1946): 7.

"Debunking State Department's Art." *New York Journal-American,* November 19, 1946, 17.

"Debunking State Department's Art." *New York Journal-American,* November 26, 1946, 17.

Devanter, Ann Van. "D. C.: USIA + CU = ICA." *Art in America* 66 (July, August 1978): 10-11.

"Distortion Laid to State Department." *New York Journal-American,* April 29, 1947, 1.

"Exposing the Bunk of So-Called Modern Art." *New York Journal-American,* December 3, 1946, 15.

"$49,000 Debunked 'American Art' on Its Way to Ashcan." *New York Journal-American,* April 6, 1947.

Frankfurter, Alfred M. "American Art Abroad: The State Department's Collection." *Art News* 45 (October 1946): 19-31.

_____. "Sixty Americans Since 1800." *Art News* 45 (December 1946): 30-39.

_____. [untitled] *Art News* 46 (May 1947): 13.

Genauer, Emily. "Art for All to See." *Ladies Home Journal,* November 1946, 103.

_____. "Still Life with Red Herring." *Harper's,* September 1949, 88-91.

Gibbs, Josephine. "State Department Art Classed as War Surplus." *Art Digest* 22 (June 1948): 9.

_____. "State Department Sends Business-Sponsored Art as U.S. Envoys." *Art Digest* 21 (November 15, 1946): 8.

_____. "State Department Shows 'Goodwill' Pictures." *Art Digest* 21 (October 1, 1946): 13.

93

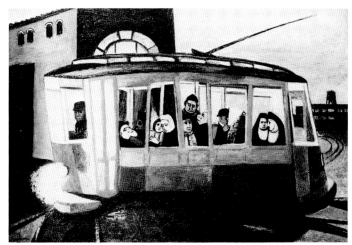

FIG. 49 Gregorio Prestopino *Trolley Car* (not exhibited)

FIG. 51 (no. 26) Werner Drewes *Balcony,* 1945

FIG. 50 (no. 71) Max Weber *Fruit and Wine*

FIG. 53 (no. 60) Gregorio Prestopino *Donkey Engine*

FIG. 52 (no. 67) Charles Sheeler *Boneyard*, 1945

FIG. 54 (no. 41) Marsden Hartley *Wild Sea Rose*

Goodrich, Lloyd. "The Federal Government and Art." *Magazine of Art* 41 (October 1948): 236-238.

_____. "Lloyd Goodrich Reminices: Part II." *Archives Of American Art Journal.* 23 (1983): 16-17.

Greenberg, Clement. "Art." *The Nation* 163 (November 23, 1946): 593-594.

"Group to Make Bid for 'Surplus' Art." *New York Times,* June 11, 1948, 21.

Hauptman, William. "The Suppression of Art in the McCarthy Decade." *Artforum* 12 (October 1973): 48-52.

Hunter, Kent. "Says U.S. 'Faked' Demand for Art." *New York Journal-American,* May 14, 1947.

Hyman, Sidney. *The Lives of William Benton.* Chicago: The University of Chicago Press, 1969.

International Exposition of Modern Art Catalogue. Paris, 1946.

"It's Striking, but is it Art or Extravagance?" *Newsweek,* August 25, 1947.

Jewell, Edward Alden. "The Art Crisis Grows." *New York Times,* May 11, 1947, section 2, p. 7.

_____. "Eyes to the Left: Modern Painting Dominates in State Department and Pepsi-Cola Selections." *New York Times,* October 6, 1946, section 2, p. 8.

_____. "Let the State Department Speak." *New York Times,* June 15, 1947, section 2, p. 10.

_____. "State Department Crisis." *New York Times,* May 4, 1947, section 2, p. 10.

Josephson, Matthew. "The Vandals are Here, Art is Not for Burning." *The Nation* 177 (September 26, 1953): 244-248.

Kaldis, Aristodimos. "The Question of Nationalism." *Art Digest,* June 1, 1943, 19.

Keith, Walling. "Please, Mam, Lay that Easel Down! I'm Neutral." *Birmingham News,* February 10, 1949, 31.

Kellman, Taissa. "Letter from Paris." *Art Digest* 21 (December 15, 1946): 18.

FIG. 55 (no. 21) Joseph De Martini *Monhegan Cliff*

FIG. 56 (no. 38) Robert Gwathmey *Workers on the Land,* 1946

FIG. 57 (no. 63) Boardman Robinson *Thomas Rhodes*

Lansford, Alonzo. "Artists Protest." *Art Digest* 21 (May 15, 1947): 16.

_____. "Sic Transit: State Department's Collection of Modern American Paintings; Final Awards to Bidders." *Art Digest* 22 (July 1948): 13.

Larson, Gary O. *The Reluctant Patron: The United States Government and the Arts, 1943-1965.* Philadelphia: University of Pennsylvania Press, 1983.

Lassaigne, Jacques. "U.N.E.S.C.O. les expositions au Musée d'Art Moderne." *Arts,* 22 (November 1946): 8.

Louchheim, Aline B. "Disputable Art Placed on Display." *New York Times,* May 21, 1948, 21.

_____. *"The Government and Our Art Abroad." New York Times,* May 23, 1948, section 2, p. 8.

McMurry, Ruth Emily, and Lee, Muna. *The Cultural Approach: Another Way in International Relations.* Chapel Hill: University of North Carolina Press, 1947.

Mangravite, Peppino. "Freedom of Expression." *American Artist* 11 (September 1947): 47.

Marchard, Jean-José. *Combat,* September 9, 1947, 12.

Marling, Karal Ann. *Wall-to-Wall America.* Minneapolis: University of Minnesota Press, 1982.

"Marshall Halts World Tour of Red-Linked U.S. Art." *New York Journal-American,* April 4, 1947.

Mathews, Jane DeHart. "Art and Politics in Cold War America." The *American Historical Review* 81 (October 1976): 762-787.

Mecklenburg, Virginia M. *The Public as Patron.* College Park, Maryland: University of Maryland Art Gallery, 1979.

[untitled] *Montgomery Advertiser,* December 17, 1952.

Morse, John D. "Americans Abroad." *Magazine of Art* 40 (January 1947): 21-25.

_____. "We Regret." *Magazine of Art* 40 (May 1947): 169.

"National Affairs: Congress Week." *Time,* February 24, 1947, 24.

Ninkovich, Frank. "The Currents of Cultural Diplomacy: Art and the State Department, 1938-1947." *Diplomatic History* 1 (July 1977): 215-237.

―――――. *The Diplomacy of Ideas: U.S. Foreign Policy and Cultural Relations, 1938-1950.* New York: Cambridge University Press, 1981.

Othman, Frederick C. "But Is It Art? Lawmakers Don't Think So." *World Telegram,* May 15, 1947.

―――――. "Scrambled Egg Art Sale." *Washington News,* May 14, 1948.

Pearson, Ralph M. "Hearst, the A.A.P.L., and Life." *Art Digest* 21 (December 15, 1946): 25.

―――――. "State Department Exhibition for Foreign Tour." *Art Digest* 21 (October 15, 1946): 29.

―――――. "State Department Requests." *Art Digest* 22 (October 1, 1947): 29.

―――――. "They Asked for It." *Art Digest* 21 (September 15, 1947): 32.

Perrett, Geoffrey. *Days of Sadness, Years of Triumph: The American People 1939-1945.* New York: Coward, McCann and Geoghegan, 1973.

Phillips, Cabell. *The 1940s Decade of Triumph and Trouble.* New York Times Chronicle of American Life. New York: Macmillan Publishing Co., 1975.

Purcell, Ralph. *Government and Art: A Study of the American Experience.* Washington, D. C.: Public Affairs Press, 1956.

"Radical Art Tour Halted." *Los Angeles Examiner,* April 4, 1947.

"Recall of Art Tour Protested to Truman." *New York Times,* May 2, 1947, 24.

Reid, Albert T. "A Letter from the State Department." *Art Digest* 21 (December 15, 1946): 32.

―――――. "Diplomatic Art." *Art Digest* 21 (December 1, 1946): 33.

―――――. "League Protests to the Department of State." *Art Digest* 21 (November 15, 1946): 32.

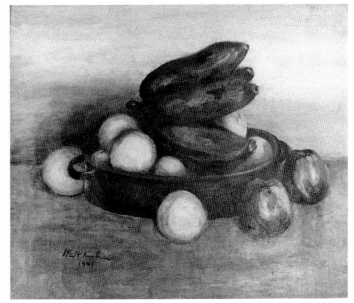

FIG. 58 (no. 46) Walt Kuhn *Still Life With Bananas,* 1941

_____. "That State Department Art." *Art Digest* 22 (August 1, 1948): 33.

"Retired American Art." *Newsweek,* July 5, 1948, 68.

Richard, Paul. "Found Art—$250,000 Worth." *Washington Post,* December 3, 1982, section E, p. 1.

Riley, Maude Kemper. "Critique of Metropolitan Show." *MKR's Art Outlook,* October 14, 1946, 2.

_____. "Marshall Orders American Paintings Cease World Tour." *MKR's Art Outlook,* April 21, 1947, 1-8.

Rushmore, Howard. "State Dept. Backs Red Art Show." *New York Journal-American,* October 4, 1946.

Schuyler, William M., ed. *The American Year Book, a Record of Events and Progress Year 1948.* New York: Thomas Nelson and Sons, 1948.

"The Secretary as Critic." *Time,* April 14, 1947, 53.

"Showing the World." *Newsweek,* October 14, 1946, 116.

Soby, James Thrall. "History of a Picture." *Saturday Review,* April 26, 1947, 30-32.

"Soviet Exhibition of the Works of National Artists in Prague." *Svobodné* Noviny, April 16, 1947.

"State Department." *Art Digest* 22 (March 15, 1948): 37.

"State Department Banned from Exhibiting Modern Art." *Washington Post,* May 6, 1947, 1.

"State Department and Modern Art." *College Art Journal 7* (Winter 1947-48).

"Surplus Art Nets $23,000 to the U.S." *New York Times,* June 25, 1948, 22.

Thomson, Charles A., and Laves, Walter H. C. *Cultural Relations and U.S. Foreign Policy.* Bloomington: Indiana University Press, 1963.

"U.S. Buys Good Works for World-Wide Tour." *New York World Telegram,* October 5, 1946.

U.S. Congress. *House Hearings before the Subcommittee of the Committee on Appropriations on the Department of State Appropriations Bill for 1948,* 80th Cong., 1st Sess. 1947, 412-419.

"U.S. to Sell 'Scrambled Egg' Art." *College Art Jornal 7* (Summer 1948).

"U.S. Will Call Experts in Art Show Dilemma." *New York Times,* May 18, 1947, 53.

"Vaporings." *Time,* June 16, 1947, 51.

Watson, Ernest W. "Let the 'Modern' Show Continue its Tour." *American Artist* 106 (June 1947): 15.

Weisgall, Hugo. *Advancing American Art.* Prague: U.S. Information Service, 1947.

Welch, Douglas, "New U. Pictures Not to be Confused with Art." *Seattle Post Intelligencer,* July 10, 1948, 1.

White, Dave. "Auburn Art Once Viewed as 'Communist, Vulgar.' " *Birmingham News,* April 26, 1981, section B, p. 2.

"Write Your Congressman." *College Art Journal* 6 (Summer 1947).

"Your Money Bought these Paintings." *Look,* February 18, 1947, 80-81.

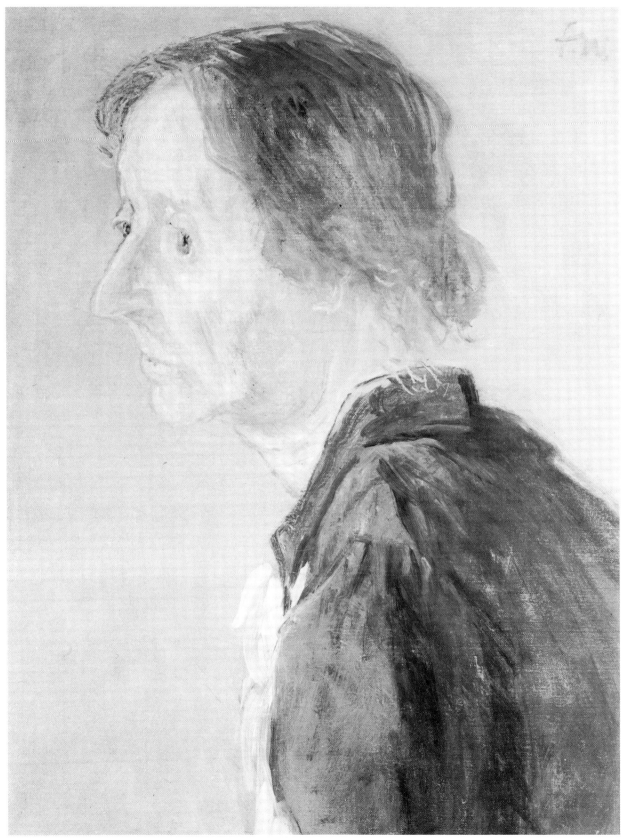

FIG. 59 (no. 69) Franklin Watkins *Portrait of Old Woman*

FIG. 60 (no. 29) Lyonel Feininger *Late Afternoon,* 1934

FIG. 61 (no. 1) Milton Avery *Summer Morning,* 1945

*Dimensions are in inches, followed by centimeters,
height precedes width.*

Advancing American Art
Original Collection:

Paintings Not Included in the Reassembled Exhibition

1. **Milton Avery** (American, 1893-1965)

 Fish Basket
 Oil on canvas
 35 1/2 × 28 (90.2 × 71.1 cm.)
 Signed, "Milton Avery" lower left

 Exhibitions: *Advancing American Art,* 1946-47.
 Location unknown

2. **William Baziotes** (American, 1912-1963)

 The Room
 Watercolor on paper
 10 1/2 × 13 1/2 (26.7 × 34.3 cm.)

 Exhibitions: *Advancing American Art,* 1946-47.
 Location unknown

3. **Ben-Zion** (American; born Russia, 1897)

 End of Don Quixote
 Oil on canvas
 30 × 25 (76.2 × 63.5 cm.)
 Signed, "Ben-Zion" lower right
 No date

 Exhibitions: *Advancing American Art,* 1946-47.
 Collection of Auburn University

4. **Ben-Zion** (American; born Russia, 1897)

 The Strangled Tree
 Oil on canvas
 26 7/8 × 36 (68.2 × 91.4 cm.)
 Signed, "Ben-Zion" lower right
 No date

 Exhibitions: *Advancing American Art,* 1946-47.
 Collection of Auburn University

5. **Rainey Bennett** (American, born 1907)

 Evening Glow
 Watercolor on paper
 21 1/2 × 18 (54.6 × 45.7 cm.)
 Signed, "Rainey Bennett '45 Evening Glow" lower right
 1945

 Exhibitions: *Advancing American Art,* 1946-47.
 Collection of Museum of Art, University of Oklahoma

6. **Cameron Booth** (American, 1892-1980)

 Clown
 Oil on canvas
 30 × 25 (76.2 × 63.5 cm.)
 Signed, "Cameron Booth" upper right; " '45" extreme
 upper right
 1945

 Exhibitions: *Advancing American Art,* 1946-47.
 Collection of Museum of Art, University of Oklahoma

7. **Louis Bouché** (American, 1896-1969)

 Maspeth, Queens
 Oil on canvas
 14 × 20 (35.6 × 50.8 cm.)

 Exhibitions: *Advancing American Art,* 1946-47.
 Location unknown

FIG. 62 (no. 50) Julian Levi *Wasteland Images,* 1943

FIG. 63 (no. 48) Yasuo Kuniyoshi *Deserted Brickyard,* 1938

8. **Raymond Breinin** (American; born Russia, 1909)

 Her Lover's Return
 Oil on canvas
 29 1/2 × 40 (74.9 × 101.6 cm.)
 Signed, "Breinin '41" lower right
 1941

 Exhibitions: *Advancing American Art,* 1946-47; *Opening Exhibition,* Georgia Museum of Art, The University of Georgia, Athens, Georgia, 11/8/48 — 1/1/49; *Paintings from the Holbrook Collection,* Southwestern at Memphis, Memphis, Tennessee, 9/22/60 — 10/13/60.
 Collection of Georgia Museum of Art, The University of Georgia, University Purchase, 1948

9. **Douglas Brown** (American, born 1904)

 Boston
 Watercolor on paper
 15 × 21 3/4 (38.1 × 55.2 cm.)
 Signed, "Douglas Brown" over initials "D.B." lower right
 No date

 Exhibitions: *Advancing American Art,* 1946-47.
 Collection of Museum of Art, University of Oklahoma

10. **Byron Browne** (American, 1907-1961)

 Woman and Bird
 Tempera and india ink on board
 24 3/8 × 20 3/8 (61.9 × 51.7 cm.)
 Signed, "Byron Brown" lower right
 1945

 Exhibitions: *Advancing American Art,* 1946-47.
 Collection of Museum of Art, University of Oklahoma

11. **Stuart Davis** (American, 1894-1964)

 Still Life with Flowers
 Oil on canvas
 32 × 40 (81.3 × 101.6 cm.)
 Signed, "Stuart Davis" lower right
 1930

 Exhibitions: *Advancing American Art,* 1946-47.
 Collection of New Trier Township High School, Wilmette, Illinois

12. **Julio De Diego** (American, born Spain; 1900-1979)

 Nocturnal Family
 Oil on masonite
 24 × 30 (60.9 × 76.2 cm.)
 Signed, "deDiego '44" lower right
 1944

 Exhibitions: *Advancing American Art,* 1946-47.
 Collection of Museum of Art, University of Oklahoma

13. **Werner Drewes** (American; born Germany, 1899)

 A Dark Thought
 Oil on canvas
 13 × 33 (33 × 83.8 cm.)
 Marked, "4 ⊕ 3" lower left
 1943

 Exhibitions: *Advancing American Art,* 1946-47.
 Collection of Auburn University

14. **Philip Evergood** (American, 1901-1973)

 Girl with Cock
 Oil on canvas
 19 1/2 × 29 1/2 (49.5 × 74.9 cm.)

 Exhibitions: *Advancing American Art,* 1946-47.
 Location unknown

15. **George Grosz** (American, born Germany; 1893-1959)

 Street Fight
 Watercolor on paper
 25 1/4 × 18 1/2 (64.1 × 46.9 cm.)

 Exhibitions: *Advancing American Art,* 1946-47.
 Location unknown

16. **Marsden Hartley** (American, 1877-1943)

 Roses
 Oil on canvas
 12 × 16 (30.5 × 40.6 cm.)
 Signed, "M.H." lower right

 Exhibitions: *Advancing American Art,* 1946-47.
 Location unknown

17. **John Heliker** (American, born 1910)

 Landscape
 Watercolor on paper
 14 7/8 × 18 15/16 (37.8 × 48.1 cm.)
 Signed, "John E. Heliker, 41" lower right
 1941

 Exhibitions: *Advancing American Art,* 1946-47.
 Collection of Auburn University

18. **Mervin Jules** (American, born 1912)

 Wagnerian Opera
 Watercolor on paper
 16 1/2 × 20 (41.9 × 50.8 cm.)
 Signed, "Jules" lower right
 No date

 Exhibitions: *Advancing American Art,* 1946-47.
 Collection of Museum of Art, University of Oklahoma

19. **Morris Kantor** (American, born Russia; 1896-1974)

 Afternoon
 Oil on canvas
 20 × 25 (50.8 × 63.5 cm.)
 Signed, "Morris Kantor" lower right
 No date

 Exhibitions: *Advancing American Art,* 1946-47.
 Collection of New York Mills Union Free School District,
 New York Mills, New York

20. **Dong Kingman** (American, born 1911)

 Piqua, Ohio
 Watercolor on paper
 14 1/2 × 21 (36.8 × 53.3 cm.)
 Signed, "Kingman '46" lower right
 1946

 Exhibitions: *Advancing American Art,* 1946-47.
 Collection of Museum of Art, University of Oklahoma

21. **Frank Kleinholtz** (American, born 1901)

 Bank Night
 Oil on masonite
 23 7/8 × 31 (60.6 × 78.7 cm.)
 Signed, "F. Kleinholtz" lower right
 No date

 Exhibitions: *Advancing American Art,* 1946-47.
 Collection of Auburn University

22. **Frank Kleinholtz** (American, born 1901)

 Floral
 Oil on canvas
 36 × 30 (91.4 × 76.2 cm.)
 Signed, "Kleinholtz" lower right
 No date

 Exhibitions: *Advancing American Art,* 1946-47.
 Collection of Museum of Art, University of Oklahoma

23. **Benjamin Kopman** (American, born Russia; 1887-1965)

 Three Clowns
 Gouache on paper
 15 1/2 × 13 (39.4 × 33 cm.)
 Signed, "Kopman" upper left
 No date

 Exhibitions: *Advancing American Art,* 1946-47.
 Collection of Museum of Art, University of Oklahoma

24. **Yasuo Kuniyoshi** (American, born Japan; 1889-1953)

 Landscape
 Watercolor on paper
 19 1/4 × 12 1/4 (48.9 × 31.1 cm.)

 Exhibitions: *Advancing American Art,* 1946-47.
 Location unknown

104

FIG. 64 (no. 66) Ben Shahn *Renascence,* 1946

25. **Julian Levi** (American, 1900-1982)

Still Life
Oil on canvas
21 × 38 (53.3 × 96.5 cm.)
Signed, "Julian E. Levi" lower left
1939

Exhibitions: *Advancing American Art,* 1946-47.
Collection of New Trier Township High School, Wilmette,
 Illinois

26. **Edmund Lewandowski** (American, born 1914)

Cemetery
Gouache on paper
18 × 24 (45.7 × 60.9 cm.)
Signed, "Lewandowski, 1946, ©" lower right
1946

Exhibitions: *Advancing American Art,* 1946-47.
Collection of Museum of Art, University of Oklahoma

27. **Lewis Jean Liberté** (American, born Italy; 1896-1965)

Rock Forms and Boats
Gouache on composition board
20 1/2 × 26 3/8 (52.1 × 66.9 cm.)
Signed, "Liberté Liberté" lower left
No date

Exhibitions: *Advancing American Art,* 1946-47.
Collection of Auburn University

28. **De Hirsh Margules** (American, born Rumania; 1899-1965)

Color Mood
Watercolor on paper
20 5/8 × 30 (52.4 × 76.2)
Signed, "De Hirsch Margulies 46" lower left
1946

Exhibitions: *Advancing American Art,* 1946-47; *Opening
 Exhibition,* Georgia Museum of Art, The University of
 Georgia, Athens, Georgia, 11/8/48 — 1/1/49; *Georgia
 Museum of Art: Dedication Exhibition,* Georgia Museum of
 Art, The University of Georgia, Athens, Georgia,
 1/28/58 — 2/22/58.
Collection of Georgia Museum of Art, The University of
 Georgia, University Purchase, 1948

29. **John Marin** (American, 1870-1953)

Sea & Boat
Oil on canvas
22 × 29 (55.9 × 73.7 cm.)
Signed, "Marin 42" lower right

Exhibitions: *Advancing American Art,* 1946-47; *Art United
 Nations,* E. & A. Silberman Galleries, New York City,
 12/10/57 — 12/28/57.
References: Sheldon Reich, *John Marin: A Stylistic Analysis
 and Catalogue Raisonnè* (Tucson, Arizona, 1970).
Location unknown, last known owner, Dr. and Mrs. John J.
 Mayers, New York

30. **Herman Maril** (American, born 1908)

In the Hills
Gouache and pencil on paper
12 1/16 × 18 1/16 (30.8 × 46 cm.)
Signed, "Herman Maril '44" lower right
1944

Exhibitions: *Advancing American Art*, 1946-47.
Collection of Auburn University

31. **Hans Moller** (American, born Germany; 1905)

The Cow
Gouache on paper
16 × 23 1/2 (40.6 × 58.4 cm.)
Signed, "Moller-46" lower right
1946

Exhibitions: *Advancing American Art*, 1946-47; *Opening Exhibition,* Georgia Museum of Art, The University of Georgia, Athens, Georgia, 11/8/47 — 1/1/48.
Collection of Georgia Museum of Art, The University of Georgia, University Purchase, 1948

32. **George L. K. Morris** (American, 1905-1975)

Shipbuilding Composition
Oil on canvas
22 1/8 × 18 1/2 (56.2 × 46.9 cm.)
Signed, "Morris" lower right
1944-45

Exhibitions: *Advancing American Art*, 1946-47.
Collection of Museum of Art, University of Oklahoma

FIG. 65 (no. 32) William Gropper *Home*

33. **Irene Rice Pereira** (American, 1907-1971)

Abstraction
Oil on canvas
30 × 38 (76.2 × 96.5 cm.)
Signed, "I. Rice Pereira '40" lower right
1940

Exhibitions: *Advancing American Art*, 1946-47.
Collection of Honolulu Academy of Arts, Honolulu, Hawaii

34. **Gregorio Prestopino** (American, born 1907)

Newspaper
Oil on masonite
38 3/4 × 30 1/4 (98.4 × 76.8 cm.)
Signed, "Prestopino" lower right
No date

Exhibitions: *Advancing American Art*, 1946-47.
Collection of Museum of Art, University of Oklahoma

106

35. **Gregorio Prestopino** (American, born 1907)

Trolley Car
Oil on canvas
30 × 36 (76.2 × 91.4 cm.)
Signed, "Prestopino" lower right
1946

Exhibitions: *Advancing American Art,* 1946-47; *Gregorio Prestopino: Retrospective,* Fort Lauderdale Museum of Art, Fort Lauderdale, Florida, 1/7/81 — 2/1/81.
Collection of Mr. and Mrs. Bernard S. Needle, New York, New York

36. **Abraham Rattner** (American, 1893-1978)

Yellow Table
Oil on canvas
23 9/16 × 28 3/4 (59.8 × 73 cm.)
Signed, "Rattner" lower left
No date

Exhibitions: *Advancing American Art,* 1946-47.
Collection of Museum of Art, University of Oklahoma

37. **Mitchell Siporin** (American, 1910-1976)

Neopolitan Nights
23 3/4 × 18 3/4 (60.3 × 47.6 cm.)
Signed, "Mitchell Siporin '46" lower right
1946

Exhibitions: *Advancing American Art,* 1946-47.
Collection of Auburn University

38. **Everett Spruce** (American, born 1907)

Canyon at Night
Oil on masonite
18 × 24 (45.7 × 61 cm.)
1945

Exhibitions: *Advancing American Art,* 1946-47.
Collection of the Dallas Museum of Fine Arts, Dallas Art Association Purchase

39. **Everett Spruce** (American, born 1908)

Turkey
Oil on canvas
25 × 30 1/2 (63.5 × 77.5 cm.)

Exhibitions: *Advancing American Art,* 1946-47.
Location unknown

40. **Nahum Tschacbasov** (American; born Russia, 1899)

Fish
Oil on canvas
20 × 15 3/4 (50.8 × 40 cm.)
Signed, "Tschacbasov '45" upper right
1945

Exhibitions: *Advancing American Art,* 1946-47.
Collection of Auburn University

41. **Nahum Tschacbasov** (American; born Russia, 1899)

Choir Boys
Oil on canvas
20 × 30 (50.8 × 76.2 cm.)
Signed, "45 Tschacbasov" lower left
1945

Exhibitions: *Advancing American Art,* 1946-47; *Opening Exhibition,* Georgia Museum of Art, The University of Georgia, Athens, Georgia, 11/8/48 — 1/1/49; *Paintings from Southern Museums,* The Mint Museum of Art, Charlotte, North Carolina, 11/4/49 — 11/30/49.
Collection of Georgia Museum of Art, The University of Georgia, University Purchase, 1948

42. **Nahum Tschacbasov** (American; born Russia, 1899)

Mother and Child
Oil on masonite
23 7/8 × 20 (60.6 × 50.8 cm.)
Signed, "45 Tschacbasov" lower right
1945

Exhibitions: *Advancing American Art,* 1946-47.
Collection of Auburn University

43. **Sol Wilson** (American, born Poland; 1896-1947)

Fisherman on Wharf
30 1/2 × 26 (77.5 × 66 cm.)
Signed, "Sol Wilson" lower left

Exhibitions: *Advancing American Art,* 1946-47.
Location unknown

44. **Karl Zerbe** (American, born Germany; 1903-1972)

The Owls
Oil on canvas
24 1/2 × 20 1/4 (62.2 × 51.4 cm.)

Exhibitions: *Advancing American Art,* 1946-47.
Location unknown

45. **Karl Zerbe** (American, born Germany; 1903-1972)

Around the Lighthouse
Oil on canvas
30 1/16 × 36 (76.7 × 91.4 cm.)
Signed, "Zerbe" lower right
No date

Exhibitions: *Advancing American Art,* 1946-47.
Collection of Auburn University

46. **Karl Zerbe** (American, born Germany; 1903-1972)

Columbus Avenue
Gouache and watercolor on flocked paper
20 × 26 (50.8 × 66 cm.)
Signed, "Zerbe" lower left
1945

Exhibitions: *Advancing American Art,* 1946-47; *Cityscape,* Oklahoma Art Center, Oklahoma City, Oklahoma, 10/29/78 — 11/27/78.
Collection of Museum of Art, University of Oklahoma

List of Illustrations

Cover Design by Wendell Jones, Montgomery, Alabama.

Designed by Julie Toffaletti, Montgomery, Alabama.

2500 copies produced by Brown Printing Company, Montgomery, Alabama in January, 1984.

Text type is Galliard, titling is Futura.

Text stock is Warren Lustro 80 lb. Gloss Enamel, and the Cover stock is Champion KromKote 12 point coated two sides.

Photography Credits

Will Brown, Philadelphia, Pennsylvania, Fig. 54.

Georgia Museum of Art Photographic Services, Athens, Georgia, Figs. 5, 15, 23, 38, 44, 62.

Henry Art Gallery Photographic Services, Seattle, Washington, Pl. 7, Figs. 20, 37, 47, 51.

Honolulu Academy of Arts Photographic Services, Honolulu, Hawaii, Fig. 63.

Humanities Research Center Photographic Services, The University of Texas at Austin, Fig. 4.

The Jane Voorhees Zimmerli Art Museum Photographic Services, New Brunswick, New Jersey, Figs. 35, 40, 52.

Museum of Art, University of Oklahoma Photographic Services, Norman, Oklahoma, Pls. 4, 6, 8, 9, 11, 12, 13, Figs. 2, 9, 13, 14, 17, 18, 24, 25, 26, 30, 34, 43, 46, 55, 56, 64.

Museum of Modern Art Photographic Laboratory, New York, Fig. 8.

Stanley Nowakowski, New York Mills, New York, Figs. 11, 50.

Scott Photographic Services, Montgomery, Alabama, Pls. 1, 2, 3, 5, 10, 14, Figs. 16, 19, 21, 22, 27, 28, 29, 31, 32, 33, 39, 41, 42, 45, 48, 53, 57, 60, 65.

United States Information Agency Photographic Services, Washington, D.C., Figs. 10, 61.

Washington County Museum of Fine Arts Photographic Services, Hagerstown, Maryland, Fig. 1.